Steve Macleod

POST-PRODUCTION
COLOUR

n. work done on a film or
recording after filming or
recording has taken place.

ava Academia
the environment of learning

An AVA Book
Published by AVA Publishing SA
Rue des Fontenailles 16
Case Postale
1000 Lausanne 6
Switzerland
Tel: +41 786 005 109
Email: enquiries@avabooks.ch

Distributed by Thames & Hudson (ex-North America)
181a High Holborn
London WC1V 7QX
United Kingdom
Tel: +44 20 7845 5000
Fax: +44 20 7845 5055
Email: sales@thameshudson.co.uk
www.thamesandhudson.com

Distributed in the USA & Canada by:
Watson-Guptill Publications
770 Broadway
New York, New York 10003
USA
Fax: +1 646 654 5487
Email: info@watsonguptill.com
www.watsonguptill.com

English Language Support Office
AVA Publishing (UK) Ltd.
Tel: +44 1903 204 455
Email: enquiries@avabooks.co.uk

ISBN 2-940373-59-0 and 978-2-940373-59-8

10 9 8 7 6 5 4 3 2 1

Design by Gavin Ambrose (gavinambrose.co.uk)

Production by AVA Book Production Pte. Ltd., Singapore
Tel: +65 6334 8173
Fax: +65 6259 9830
Email: production@avabooks.com.sg

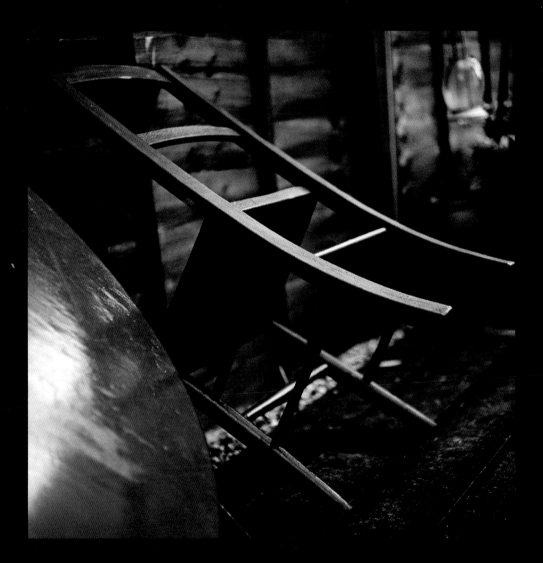

181 Chair (above)

Shot on a warm summer evening, this shot captures the feeling of last light.

Photographer: Steve Macleod.

Technical summary: Rolleiflex 2.8GX, f5.6, Fuji Superia 400 film processed at normal, drum-scanned negative manipulated in Photoshop.

Contents ▷

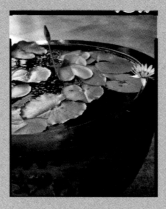
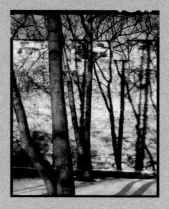

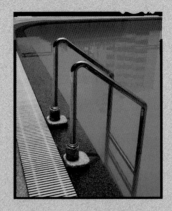

This book features dedicated chapters that explain how to successfully use post-production techniques in photography. An initial overview of the equipment required leads to an examination of the differences between film and digital techniques and black-and-white and colour methods. Later chapters examine how more advanced processes can be utilised to create stunning images, both on film and digitally. Finally a review of the techniques required for successful self-promotion and presentation is included.

Main chapter pages
These offer a précis of the basic concepts that will be discussed.

Headings
Headings run throughout each chapter to provide a clear visual indication of your current location.

Introductions
Special chapter introductions outline basic concepts that will be discussed.

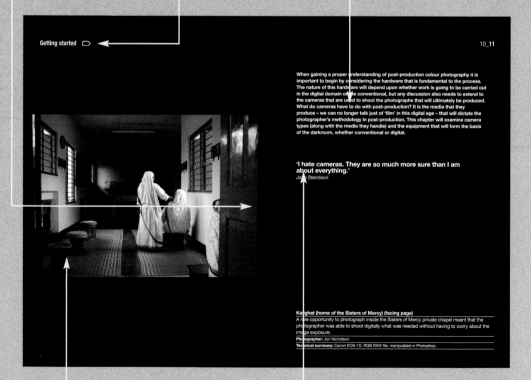

Getting started ▷ ←

10_11

When gaining a proper understanding of post-production colour photography it is important to begin by considering the hardware that is fundamental to the process. The nature of this hardware will depend upon whether work is going to be carried out in the digital domain or the conventional, but any discussion also needs to extend to the cameras that are used to shoot the photographs that will ultimately be produced. What do cameras have to do with post-production? It is the media that they produce – we can no longer talk just of 'film' in this digital age – that will dictate the photographer's methodology in post-production. This chapter will examine camera types (along with the media they handle) and the equipment that will form the basis of the darkroom, whether conventional or digital.

'I hate cameras. They are so much more sure than I am about everything.'
John Steinbeck

Kalighat (home of the Sisters of Mercy) (facing page)
A rare opportunity to photograph inside the Sisters of Mercy private chapel meant that the photographer was able to shoot digitally what was needed without having to worry about the image exposure.
Photographer: Jon Nicholson.
Technical summary: Canon EOS-1D, RGB RAW file, manipulated in Photoshop.

Introductory images
Introductory images give a visual indication of the context for each chapter.

Quotations
The pertinent thoughts and comments of famous photographers, artists, philosophers and photographic commentators.

Diagrams

Diagrams explain technical concepts clearly and concisely.

Running glossary

A running glossary is included where each initial use of a technical term or phrase is explained at the point where it first appears.

Image captions

Captions call attention to particular concepts covered in the text and almost always list equipment used, exposure details and any other relevant technical information.

Images

All the images have been carefully chosen to illustrate the principles under discussion.

The word 'photography' is a compound of two Greek words 'phos' (light) and 'graphis' (stylus, or paintbrush), which, when combined, can mean 'drawing with light'. Today this translation echoes as much in digital and analogue post-production techniques as it does in shooting the actual photograph itself.

Digital image capture has revolutionised the way in which we now represent the world around us and the speed at which images are shared. It is encouraging, therefore, that I find myself writing a volume on both analogue and digital techniques. Digital photography does not take away from analogue and as long as people are passionate about these practices, there will always be artists keen to take the time and learn the skills necessary to craft a fine print.

Whether analogue or digital, colour processing and printing requires the same discipline and methodical approach used in black and white, but in other respects, the two are quite different. Photographic imaging is all about the capture and control of light, and understanding the capture and manipulation of that light to create the desired result is the key to successful photography. The added dimension of colour can often add to the success or failure of a colour image.

Having worked in a professional imaging industry for many years I have experienced first-hand the great advancements in digital technology as well as the domination of colour photography across the market. It has not always been this way, however. Black-and-white photography predates colour by some margin and it was, for many years, the standard method of capturing images adopted by amateur and professionals alike. The observations made here are intended to provide useful working methods. I do not profess to know everything, but all my findings are based on my twenty-year experience of working with photographic images.

Getting started
This chapter looks at the various pieces of equipment available and the similarities and differences between a digital and traditional darkroom.

Film and digital file formats
Here, an introduction to the construction of film and digital images is offered, as well as an overview of the processes involved in scanning images.

Basic image production
This chapter looks at how to create a simple print from film, as well as basic image sizing and digital colour and exposure techniques.

Advanced analogue techniques
Understanding colour composition in prints and how to balance this and compensate for discrepancies are key to producing an accurate and beautiful print.

Advanced digital output
This section analyses more advanced colour correction techniques and retouching and sharpening techniques, as well as digital printing processes.

Presentation and exhibiting
This final chapter will discuss ways in which photographs can be assembled and presented for successful pitches and commissions.

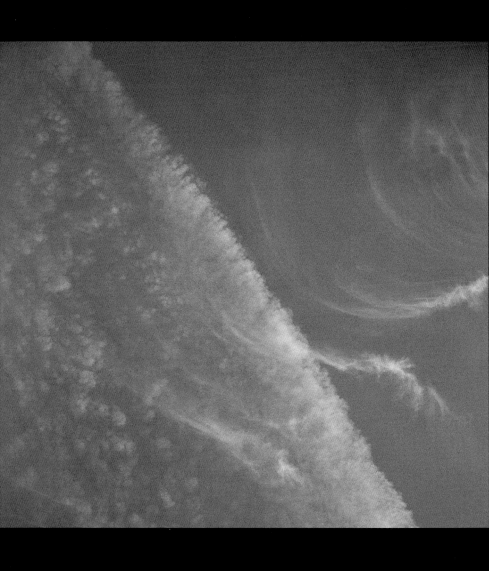

Blue Sky (above)

Shot in Finsbury Park, London.

Photographer: Steve Macleod.

Technical summary: Rolleiflex 2.8GX, Kodak Portra 400nc (natural colour) film, f11 1/60sec.

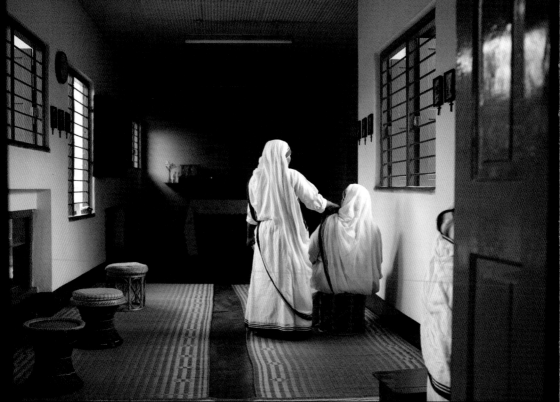

When gaining a proper understanding of post-production colour photography it is important to begin by considering the hardware that is fundamental to the process. The nature of this hardware will depend upon whether work is going to be carried out in the digital domain or the conventional, but any discussion also needs to extend to the cameras that are used to shoot the photographs that will ultimately be produced. What do cameras have to do with post-production? It is the media that they produce – we can no longer talk just of 'film' in this digital age – that will dictate the photographer's methodology in post-production. This chapter will examine camera types (along with the media they handle) and the equipment that will form the basis of the darkroom, whether conventional or digital.

'I hate cameras. They are so much more sure than I am about everything.'
John Steinbeck

Kalighat (home of the Sisters of Mercy) (facing page)
A rare opportunity to photograph inside the Sisters of Mercy private chapel meant that the photographer was able to shoot digitally what was needed without having to worry about the image exposure.

Photographer: Jon Nicholson.

Technical summary: Canon EOS-1D, RGB RAW file, manipulated in Photoshop.

Cameras

Unlike most applied crafts, photography is unique and, indeed, fortunate, in that a vast array of hardware equipment can be employed to produce an image. Of course, it has been something of a mantra in photography that the camera a photographer uses is not important; it is how he/she uses it that is important. This is true to a point: a good photographer can produce great results from a very average – in specification terms – camera, while an unskilled user is unlikely (unless by luck) to create good images with even the latest high-spec auto-everything camera.

Up until 1914 most cameras used the more delicate and clumsy-to-handle sheet or roll film. The single lens reflex (SLR) camera, now the staple of many professionals, debuted in 1933 but there was to be a three-year wait until a 35mm version appeared – a format that later came to dominate (in terms of photographic quality) the world of photography. Cameras that use 35mm film range from basic compacts through to top flight professional SLRs; they can be used across a wide range of conditions and offer good image quality. Only when work demands better do photographers need to resort to something that produces a larger negative.

Of course, the mighty 35mm format, along with many of the other film formats, is now beginning to be trounced by the exceptionally fast rise – right across the board – of digital cameras. After a modest start, digital cameras have come to dominate all market segments (with the notable exception of formats that offer much larger image sizes). This is not to say that all film cameras are now redundant – they are still widely used and, although the numbers are smaller, new models are being launched all the time. Here we will take a look at the camera marketplace today and see how different models address different needs. They have been divided roughly in the same way that the camera manufacturers and photography equipment suppliers do, into categories based on price and abilities.

Entry-level cameras

Even prior to the arrival of digital photography, the simple compact cameras that comprised this class were numerous and very popular. Now, both analogue and digital cameras in this category are intended for the mass market and, in particular, those users that do not want to know about the technicalities of photography and just want great photos in the widest range of situations. Digital cameras now provide the greater number of models in this class and by far the greatest volume in terms of sales. These cameras are comparatively inexpensive and although they tend, in general, to offer little in the way of user controls (they are mostly auto-everything models), they are capable of good results. Digital compacts will offer resolutions of up to six megapixels and are sufficient for producing good A5-sized prints.

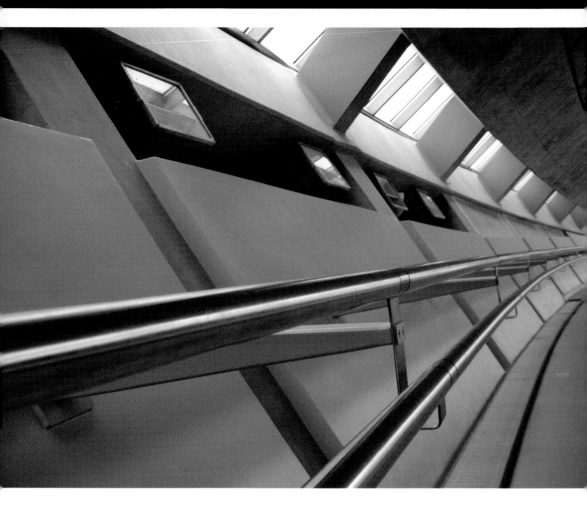

Duxford interior (above)

Shot on a Sony Cyber-shot, this image shows the effects that can be achieved with a compact camera.

Photographer: Steve Macleod.

Technical summary: Sony Cyber-shot DSC P200,1.9mb jpeg, 7.9 focal length, 08 sec.

Intermediate cameras
Intermediate cameras comprise all those models that sit between the simple point-and-shoot compacts and the more highly specified cameras that are the preserve of the professional. This category can be further divided into three groups:

Compact cameras: not the point-and-shoot variety, but rather those models that allow the photographer a degree of control. That degree tends to vary from model to model, but photographers who use these cameras (either as a main camera or as an adjunct to, say, an SLR) would benefit from either manual control options or extended exposure control. Both film and digital cameras fall into this category; digital cameras will offer resolutions of up to ten megapixels.

Hybrid cameras: a hybrid of the compact camera and the SLR, these cameras have the look of an SLR and the functionality of a compact. They boast large, powerful lenses but, unlike those of an SLR, they are not interchangeable. These cameras are less pocketable than compacts but make up for it in better image quality. A wide range of models are available, from the simple (with limited control options) through to those that rival SLRs in their controls. Expect image resolutions of up to ten megapixels. Since the demise of the Olympus IS ranges, there are no film cameras in this category.

Entry-level SLRs: designed for the photographer who is more an enthusiast than an aspiring pro, entry-level SLR cameras boast all the benefits of an SLR (including interchangeable lenses, clear viewfinder and high-quality metering) in a more compact body than a professional's SLR. Controls – and the amount of control – will be less than on the professional models but as a main camera or a second body, they provide a very cost-effective route into high-quality images. Different models offer resolutions up to 12 megapixels.

Nikon D40 digital SLR
Intermediate-level SLRs are now so good that many professionals use them as back-up kit to higher-end models.

Canon EOS 3000V film SLR
35mm film SLRs are now very inexpensive and are a great way to learn the craft of exposure control and camera knowledge.

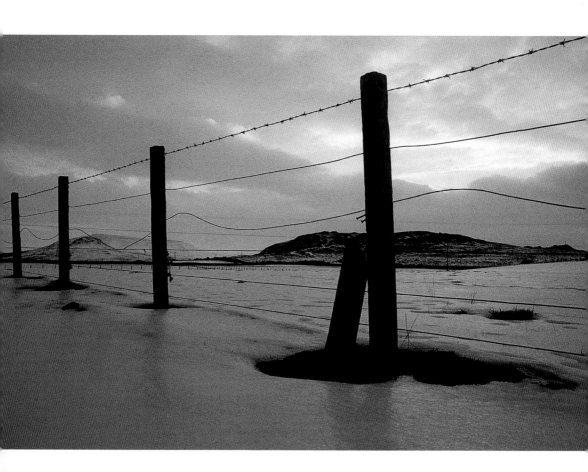

Snow, Helshetter, Caithness (above)

Shot on 35mm film, the light in this shot was very low and needed an exposure of two seconds.

Photographer: Steve Macleod.

Technical summary: Nikon FE, 35mm Fujicolor Reala film, exposure of 2 sec.

Professional cameras

The professional user will almost always choose an SLR camera and today, this generally means a digital SLR. All the big names in camera manufacture boast a number of models to satisfy the most demanding of photographers and often offer compatibility with the lenses and most other accessories that the photographer might have accumulated with film versions of the same marque's SLRs.

In general, photographers tend to use digital SLRs that are heavily influenced by, and share many design features with, 35mm SLRs but there are some alternatives to consider: for example, there are digital backs that can be used in place of the film backs used by medium-format cameras. The big names in medium-format photography, such as Hasselblad and Mamiya both offer digital backs and even complete systems based around digital equivalents of medium format. Rangefinder models are also available. These handle in a similar fashion to 35mm cameras except that a coupled parallax device on top of the camera measures the distance to the object. Models from Leica are probably the exemplars of these and they are now available in both digital and film versions.

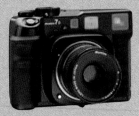

Mamiya 7MkII Rangefinder camera

A medium format camera ideal for landscape applications.

'The camera is much more than a recording apparatus. It is a medium via which messages reach us from another world.'
Orson Welles

Author's tip

Unlike film cameras that, perhaps rather obviously, use film to store images, digital cameras – except those directly connected to a computer – save images to memory cards. It is convenient to think of these as digital film although the card itself will have no effect on the quality of image; it is a simple repository of digital data. Memory cards will be discussed in more detail in the following chapter.

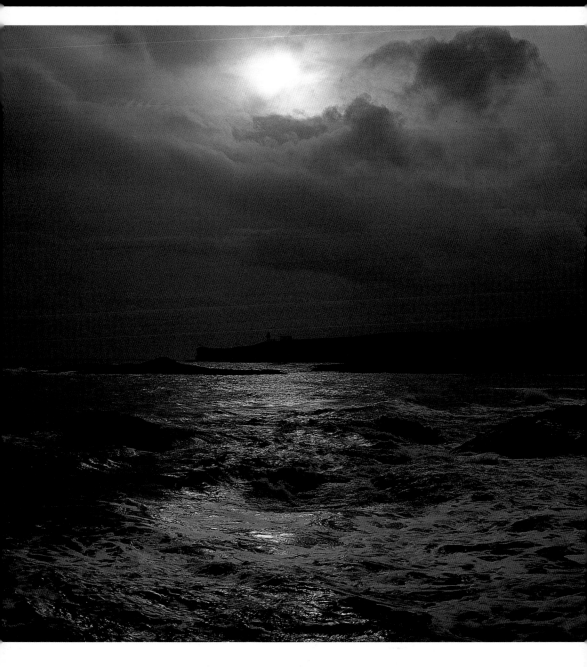

Storm, Stonehaven (above)

Moving up to a medium-format camera demands a different approach to taking photographs.

Photographer: Steve Macleod.

Technical summary: Hasselblad CM.

Large-format cameras

When the ultimate in quality is demanded by clients, even medium format will be insufficient and the photographer will have to resort to cameras that handle 5" x 4" sheet film, or larger: up to 10" x 8". Increasing quality in film stock has rendered the largest of cameras virtually obsolete because the same effective resolution can now be obtained with a smaller model. Their modular construction – using bellows extensions and adjustable front and rear planes – allows the camera to be manipulated to align image planes, particularly useful when shooting interiors or architecture where conventional cameras would suffer converging verticals or insufficient depth of field. There are also digital backs available for these cameras. These produce digital files of very high resolution. File sizes of up to 117mb/39mp and 35 frames per minute can be produced and stored to either a memory card (as in a conventional camera) or a directly-connected computer. These systems are frequently hardwired to processing software such as Capture One RAW workflow software, an application dedicated to the accurate capture of high-resolution digital images.

Specialist cameras

Falling outside these categories are specialised cameras designed for very specific uses. For example, companies like Seitz produce panoramic digital cameras. Once the staple of landscape cameras, the 'big Fujis' shoot 6cm x 17cm negatives and slides that make for fantastic panoramic images. The Seitz is the digital equivalent. Along with these there are extra-wide digital panoramic cameras and even those capable of shooting 3D images (or multiple images for combination into 3D images).

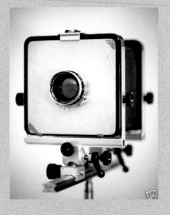

Phase One P45 back
A large-format digital back is ideal for high-end professional use, but comes at a cost.

Arca Swiss 5" x 4" monorail camera
A popular rail-type large-format camera system.

Untitled still life 3 (above)

Shot on a monorail and in a studio setting meaning that time could be taken to get the composition right and multi-exposures could be used to complete the image.

Photographer: Steve Macleod.

Technical summary: Arca Swiss 5" x 4".

The darkroom

Colour darkrooms can be forbidding places. Colour film is sensitive to all light so much of the time spent working will be in complete darkness, rather than by the pale but satisfying glow of a safelight. However, despite the proliferation of digital imaging, the colour darkroom is still popular and it has many supporters. In this section we will examine the key equipment needed for equipping a colour darkroom. If graduating to colour from black-and-white photo processing, it will be clear that much is similar but that there are also some interesting additions; additions that, be assured, will make processing life much easier.

Darkroom ergonomics

With any darkroom space, the layout must be cleverly planned; that planning is crucial for a colour darkroom because of the need to work – for at least part of the time – in complete darkness. Begin by making a checklist of all the hardware and materials that will be needed (this chapter will be a useful start) and gain an understanding of how the separate components need to work together.

Perhaps the most noticeable difference between a colour darkroom and its black-and-white counterpart is that it is, so far as the user is concerned, a completely dry space. The paper is normally processed through an RA-4 paper processor – a totally enclosed environment in which the chemistry is sealed. Exposed paper is passed from the enlarger through this machine where it is, in turn, passed into the developer and bleach-fix chemistry (the key stages in processing colour papers). What comes out the end is a light-fast, almost dry print. It is important to consider a layout that leads to an efficient workflow. The illustration opposite shows a good example.

Good ventilation is important in any darkroom but is especially important in a colour one. Some chemicals can be very unpleasant and it does not take long for fumes to build up in a confined space. Professional darkrooms have passive inlets and forced extraction ventilation systems, which are ideal in these spaces. A light-safe inlet vent placed low down in the darkroom door and (ideally) a light-tight forced extractor fan placed on the opposite wall are nearly as good. If neither of these options are possible, the minimum provision should be a light-tight extractor fan.

Colour processing machines generate a lot of heat (from their motors and by virtue of the fact they contain warmed chemicals) and this can also create problems if it finds its way back through to the darkroom. This is minimised in commercial spaces with adequate extraction above the machine, drawing the air away from the work area, as dictated by health and safety requirements. However, it may be necessary to make do with a lesser system so, if this is the case, follow manufacturer's instructions and advice.

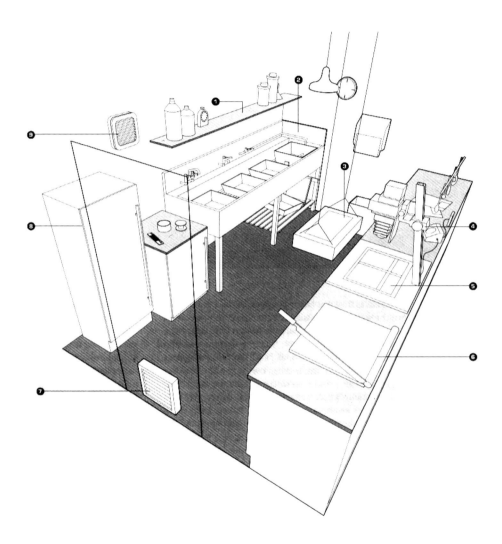

Diagram of a darkroom

Schematic view of a typical professional darkroom. Wet and dry areas kept separate, facing each other.

1 Shelf for processing chemistry
2 Sink with trays and wash unit
3 Safelight
4 Enlarger
5 Print easel

6 Paper cutter
7 Safe light ventilation
8 Storage cupboard
9 Extractor fan

The enlarger

Most enlargers in general use today, even in darkrooms that concentrate on black-and-white work, are colour models. Many of these – if not most – tend to be models made by Durst, a company with a long and proud heritage in enlarger design. Other models that may be encountered vary from the simple, basic but effective Durst 138 through to the dichroic-head enlargers that are designed to offer highly saturated colour filtration, essential for colour print production. The latter have a higher initial cost but do provide a much better filtering capability.

In use, the enlarger is designed to simultaneously expose a sheet of colour photo paper to red, green and blue light. Colour paper, which today is almost invariably RA-4, contains three colour-sensitive layers that create respectively cyan, magenta and yellow coloured dyes once processed in the corresponding RA-4 chemistry. When working with negatives it is important to be aware that red light from the enlarger head stimulates the cyan dye, green the magenta and blue the yellow. This is where it is easy to get confused; it is important to remember when working on producing the perfect print that as more red is introduced into the light stream, the more cyan the print appears. Similarly, with more green, the more magenta the print will appear, and by increasing cyan the more yellow will be evident.

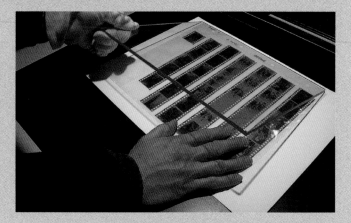

Colour enlarger

A professional colour enlarger such as this is very robust.

Processing colour negatives

It is important to remember when processing negatives that the more red light that is emitted from the enlarger head, the more cyan the print will appear. Similarly, the more green light, the more magenta the print will appear and the more cyan, the more yellow the print will be.

Lenses, easels and enlarger peripherals
The enlarger is actually the heart of a system that also comprises lenses, an easel and some other peripherals.

Lenses, very much like cameras, can determine the quality of the final print. Utilise the best enlarger lenses available in order to provide sharp and consistent results. A good enlarger lens is an investment and Schneider, Rodenstock and Nikon lenses are all reliable brands. As with camera lenses, the best results come from using the best lenses; average-quality lenses will deliver mediocre results: do not compromise!

Easels are fundamental to consistently well-presented and thought-out prints, yet surprisingly the piece of equipment most commonly missing from many darkrooms is the easel. The easel is the board that sits on the baseboard of the enlarger and holds the paper in place. It is designed to hold the paper flat so that the image can successfully be focused on the surface. Some hold paper by using a tacky surface to which the paper can stick (very gently). Others use interlocking L-shaped blades to secure the edges of the paper. These can also be used to frame the print and provide a good border.

'Accessories' is something of a misnomer as the following are pretty much essential. A focus finder is a small reflex viewing device that can be placed on the easel to help establish pin-sharp focus. It provides a magnified image at eye level. A timer is also key in any darkroom, although in a colour darkroom it may be necessary to use a device that can be viewed clearly only by the dim reflected light of the enlarger lamp (reflected from the paper) or one that has an audible count.

A standard negative carrier
The device that holds negatives
in place in the enlarger.

Lenses
A typical darkroom
enlarger lens.

Film and paper processing equipment

Equipment for processing both film and paper is generally designed to be used – once the media is loaded – in daylight. Film processing is done using film tanks where rolls of film are installed on spirals (that allow the long lengths of film in, say, a 35mm cartridge to be successfully processed in a small quantity of chemical) that are then sealed from the ingress of light so that processing can proceed. Loading film on the spirals in the dark is relatively easy for 35mm film, with its stiff backing. However, it is somewhat more difficult for the thinner-based (and wider) roll film formats. The best results will be obtained with plenty of practice until loading in complete darkness becomes second nature.

Paper processing uses a similar processor, into which chemicals are preloaded. Processors allow the temperature of the chemicals to be precisely maintained and once the paper has been inserted, following its exposure in the enlarger, the lights can be turned on and the delivery of the print awaited.

E6 film processor

An example of a professional film processor, as used by many professional imaging laboratories. Although colour film can be tank- and tray-processed, it is often better to take it to a professional laboratory where the process can be correctly controlled.

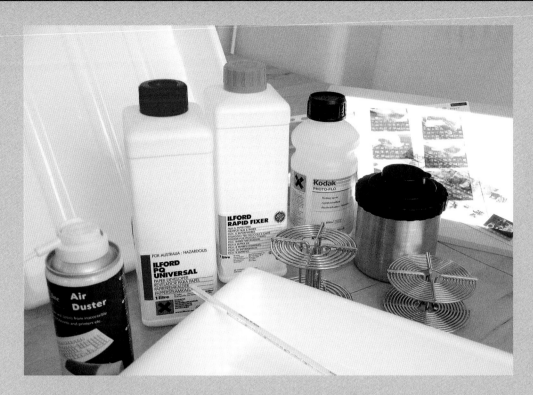

Processing chemicals
Always use processing chemicals in a well-ventilated darkroom.

Processing chemicals

With regard to both film and paper processing, it will be necessary to make provision for the convenient storage of the chemistries that need to be used. Chemicals designed for colour processing tend to have a shorter shelf life than those used for black-and-white processing and are more prone to damage from oxidation. For this reason it is advisable to follow manufacturer's suggestions on mixing the chemicals and on storage. Storage bottles that allow the exclusion of air (the obvious principle cause of oxidation) and small mixes of chemicals are widely available in photographic equipment suppliers although many chemistries rely on chemicals that are mixed from a concentrate as a one-shot solution, to be discarded after a single use.

Digital workspace

The digital equivalent of the darkroom is the computer workstation or, quite simply, a desktop computer or laptop. The truth is that today just about any computer is sufficient for digital image manipulation. Of course, some computers will be more suitable for image manipulation than others: those with larger amounts of memory, for example, will work more swiftly and productively. A large screen can help too, enabling the photographer to work on an image in greater detail or to see more of an image at one time.

It is, then, easy to see why digital photography has made such inroads when all that is needed for producing images is the same computer that is used daily for emails and printing letters. Of course, the dedicated digital darkroom worker will require some ancillary equipment too, but even the most extensive of digital darkrooms – the colloquial term for a computer system that is dedicated, more or less, to image manipulation – will require less space and be more efficient and cost-effective than a traditional darkroom.

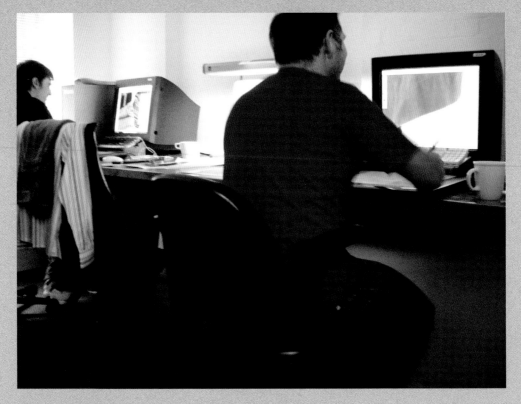

A digital creative suite
A good working digital post-production environment.

The computer

It is, perhaps, stating the obvious to say that the computer will be the heart of your digital imaging system, so what type of computer is best and what specification does it need to meet? According to Adobe, whose Photoshop is the default application for almost all photographers, the specifications required of a Windows computer are as follows:

- Intel® Pentium® 4, Intel® Centrino®, Intel Xeon®, or Intel® Core™ Duo (or compatible) processor
- Microsoft® Windows® XP with Service Pack 2 or Windows® Vista™ Home Premium, Business, Ultimate, or Enterprise (certified for 32-bit editions)
- 512MB of RAM
- 64MB of video RAM
- 1GB of available hard-disk space (additional free space required during installation)
- 1,024 x 768 monitor resolution with 16-bit video card
- DVD-ROM drive
- QuickTime 7 software required for multimedia features

For a Macintosh:

- PowerPC® G4 or G5 or multicore Intel processor
- Mac OS X v.10.4.8
- 512MB of RAM
- 64MB of video RAM
- 2GB of available hard-disk space (additional free space required during installation)
- 1,024 x 768 monitor resolution with 16-bit video card
- DVD-ROM drive
- QuickTime 7 software required for multimedia features

Almost all computers in use today will have sufficient resources to accommodate all the above.

There is, however, a difference between 'sufficient' and 'ample' specifications, which will make applications like Photoshop excel. For digital image manipulation applications to work at their best, a computer that exceeds the specifications noted above (with regard to the hard-disk space and the amount of RAM memory) will be essential.

Unlike other forms of memory found in a computer (such as hard-disk space), RAM – random access memory – can be likened to the 'thinking space' on a computer. The more there is, the faster the computer can work and the more data that can be held in the memory at any one time. Consider an amount at least double the recommended level for applications to work at their best.

The speed of the computer – measured in megahertz (MHz) (actually referring to the speed of the CPU, the central processing unit), is also significant. The higher the speed of the CPU the faster the operation. For 2D displays – which includes photographic and imaging work – a speed of 1.5Ghz should be considered minimum.

Displays

The Cathode Ray Tube (CRT) that was once the staple for computer displays has now been almost totally superseded by the Liquid Crystal Display (LCD) variety, which is substantially more compact and provides increased contrast. Photographers look at this with some ambivalence: though CRT models are more prone to temperature fluctuation which will affect colour appearance, they are easier to calibrate manually than the LCD variety. **Calibration** is essential to ensure colour consistency between the original image, screen projections and prints. To overcome this temperature change it is best to switch on the monitor and leave for 20 minutes before proceeding and try to calibrate on a weekly basis.

CRT display

Cathode ray tube displays are still popular with professional retouchers as they can be manually calibrated.

LCD display

Liquid crystal displays provide increased contrast and thus sharper-looking images, but are harder to manually calibrate.

calibration the correlation of colours in a computer display with those of a standard set. It is important to calibrate monitors and other peripheral displays so that they display colours accurately

inkjet printer a computer printer that uses a technique where minute quantities of ink are sprayed on to paper. Many inkjet printers can produce photo prints but some – those with more ink colours – offer a far higher quality of printing

USB Universal Serial Bus, a communications system between a computer and peripherals (including cameras) for the transfer of data

Printers

Images produced on a computer can be destined for print, the web or distribution via disk. Whatever the ultimate destination, most, if not all, imaging workstations will have a printer attached. For most users this will be an **inkjet printer**. These relatively humble devices have been around for some time now and many are capable of photographic-quality output. Those models that are widely available can print up to A4 prints, some to A3. The printing process will be examined more closely in later chapters.

Input and output devices

To make the transition between camera and printer or website, a number of input and output processes will need to take place:

Card readers allow the transfer of digital image files to a computer. To get images on to a computer to begin the editing process the computer can be connected directly using **USB** or FireWire cables (which will usually be provided with the camera). This allows the computer and camera to liaise and transfer the images stored on the camera's memory card. However, a more efficient method, which does not rely on using the camera to merely read files from a card, is to use a card reader. This diminutive device attaches to the computer (again, directly via a USB or FireWire cable) and allows the user to slip in a memory card. The memory card that stores all the photographic data can then be read directly. One of the benefits of memory card readers is that most are compatible with several different memory cards – so one can be used to read cards from more than one camera model.

Scanners are also an essential piece of kit as they enable the analogue photographer to work on an image digitally. Scanners come in two main types: the CCD flatbed, also known as a 'desktop' scanner, and the PMT laser high-end drum scanner type. Flatbed scanners, designed for scanning prints, negatives and transparencies, use charge coupled device (CCD) technology for creating images. High-end drum scanners (most commonly used by professional imaging labs) use photomultiplier tube (PMT) technology. PMT scanners are very adaptable, particularly when it comes to controlling and smoothing out film grain.

Graphics tablets are used by many photographers as an alternative to a mouse when applying effects and manipulations to digital images. Although a versatile device, the mouse does not offer the degree of control that is often needed. Instead some photographers resort to graphics tablets. Originating in Japan, the graphics tablet is a pressure-sensitive pad that is controlled via a pen-like stylus. They come in various sizes from around A5 up to A3, These devices allow the operator to move around images in a more organic method and often emulate many drawing and painting styles. The most popular devices are produced by the company Wacom.

External storage devices allow image files to be stored safely for long periods of time. Once an image has been manipulated, it will need to be stored as a new file. This file will be based upon the data included in the original image but will also include all the information acquired from the modifications that have been applied. It is wise to keep both the original and the modified files safe for future use. Image files are often stored on the computer's **hard drive**, which is usually adequate: hard disks today are large and have the capacity to hold extensive libraries. However, it is wise to keep a copy of images elsewhere, in case the computer hard drive fails and precious image collections are lost.

Most photographers will resort either to a separate external hard disk (which can be connected to another computer, should the need arise) or on CD/DVD discs. Some, determined to account for all eventualities, will use both.

As collections of images grow and become potentially more valuable (both in terms of monetary value and memories for those featured in the images), it is important to ensure that at least two copies of images are available. External hard disks are now relatively inexpensive and it is perfectly viable to have a couple attached, each with a mirror copy of the files. Having image files stored in this way gives much easier access to images than if libraries are stored on CD/DVD discs.

Wacom graphics tablet
The graphics tablet allows for accurate post-production manipulation using a pen and tablet format.

Epson flatbed scanner
A CCD flatbed scanning device is often used for bulk scanning at lower resolutions.

Drum scanner
A professional drum scanning device provides the optimum raw file.

hard drive the component within a computer that stores data
interface the point at which two systems meet
image manipulation application software designed for the manipulation and editing of digital images. Photoshop is the most renowned of these
metamerism the build up of red, green and blue dots, which are used to display colour

Software

A computer, per se, does not allow for image manipulation: it needs software loaded to do so. As we've already seen, that software is most commonly Adobe's Photoshop. Since its inception in the early 1990s it has been the application favoured by professional photographers. This is down to two attributes.

Firstly, it has an **interface** that, whilst not ideal for the newcomer or novice, allows for very efficient workflows. Second, it has all the tools and features that a photographer and those involved in the image reproduction business require (and quite a few more besides). Essentially, to become competent in digital image manipulation the photographer must also become proficient in an **image manipulation application**.

Photoshop is also well integrated into other imaging and design applications from Adobe (including the desktop publishing application InDesign and the design and drawing application, Illustrator) reinforcing its pre-eminent position.

Calibration devices

An ongoing problem for photographers working in the digital domain is the difficulty in matching what is on screen to what is shown in the final print output. This is unsurprising given that images seen on-screen utilise transmitted light whereas prints utilise reflected light – there will always be slight differences, no matter how well the display is calibrated.

As seen earlier, when viewing prints, the quality of light that they are viewed in will alter the tone of the print – the **metamerism** of colour can show up if prints are viewed in the wrong light.

Adobe Gamma is an effective way to manually calibrate display monitors, and is provided as a Photoshop application. The GretagMacbeth Eye-One system incorporates a spectrophotometer, which measures the light wavelength and intensity of any type of display. Alternatively, the ColorVision® Spyder is a colourimeter device, measuring varying light wavelengths.

Whether working in analogue or digital, an essential part of being a successful photographer is understanding the ways in which the image that is shot is recorded on camera and transferred to print. This, in turn, enables the photographer to understand why images may take on inaccuracies such as colour casts, dust and scratches or practical problems such as developing or data transfer failures.

Here, a basic introduction to digital file formats and workflows is offered, in addition to an overview of colour film construction and basic steps in film processing. When practising photography, it is important to keep track of all images and to ensure that they are stored and labelled properly – something of increasing importance, given the rate at which digital photography is growing in popularity, even among professionals. Scanning images is also covered here, as many photographers now prefer to shoot on film and then scan images in to be worked on digitally.

'...words and pictures can work together to communicate more powerfully than either alone.'
William Albert Allard

Summer sunset (facing page)
Transparency film can provide a much more saturated and vibrant colour range than colour negative.

Photographer: Steve Macleod.

Technical summary: Nikon FM2, 35mm transparency film, E6 processing at +1/2.

Workflow

When the shutter release of a camera is pressed, a train of events is set in motion that will ultimately end up with an image that can be enjoyed by its viewers. Here we take a look at the various stages involved in this process. These have been separated broadly into **analogue** and **digital** workflows although, as can be seen, there is a degree of overlap.

Analogue workflow
For conventional, film-based photography the following stages will be worked through:

- Shoot images
- Process film
- Either:
 Prepare the film for printing conventionally OR
 Scan the film to produce digital image files to continue handling digitally
- Produce a contact sheet
- Produce a test print
- Produce a basic print
- Produce a final print
- Present the results

Digital workflow
When shooting digitally the workflow is similar but with obvious variations:

- Shoot images
- Directly or indirectly download images to computer
- Save, organise and manage images
- Apply digital corrections to the image
- Apply any final correction
- Save the manipulated image
- Output to print, web or disk
- Present the results

In this, and the following, chapters each of these stages will be more closely examined.

analogue a method of recording data in its original form in a continuously varying way, rather than in numerical form, as in digital recording. Conventional film photography is an example of analogue data recording

digital the representation of data (an image, video or audio track) as a digital code that can be interpreted by a computer. Unlike analogue, this code can be easily and effectively copied and modified

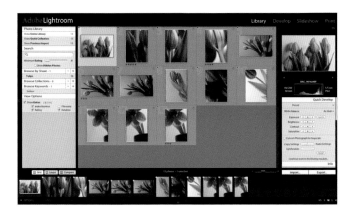

Adobe Photoshop
Lightroom library
Workflow applications, such as Adobe's Lightroom, are designed for applying corrections to batches of images as well as individual shots. It is possible to review and, if necessary, correct a range of deficiencies for all the shots taken on an assignment.

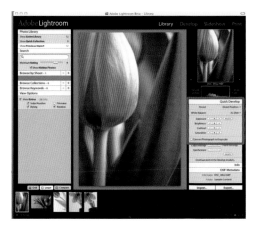

Quick development
Where image editing applications have quick fix tools, workflow applications have quick development tools. Using slider controls it is possible to quickly correct problems with the original shots such as exposure, brightness and colour saturation using a single control panel.

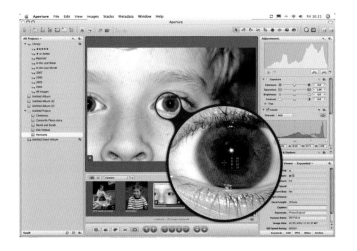

Magnifying loupe
Taking cues from the photographer's magnifying loupe, workflow applications (here Apple's Aperture) allow users to examine precise areas of a shot more quickly that would be possible in a conventional image editing application.

Colour film

Unlike monochrome (black-and-white) film, colour film exists in two formats: **positive** (used for slides and transparencies) and **negative** (used for print).

Positive transparency, or colour reversal, film used to be the format of choice for most photographers. This was for two reasons: firstly, it is viewed by transmitted rather than reflected light and so provides brilliant and deeply saturated colours; secondly, the transparencies produced are from the original film and do not involve a second stage (such as printing from a negative) for viewing. Hence there is less opportunity (as is unfortunately the case with negative files) for the photographer's original work to be compromised.

When using transparency film be aware that there is little latitude for under or overexposure. When this is translated into images situations may arise where, at the worst, highlight and shadow detail can easily be lost. Contrast will be very high. It can be very unforgiving but is great for gaining that essential experience of what terms like exposure control and latitude really mean. Transparency film also has an increased sharpness and brilliance to it, and the controls of the camera have a direct relationship with the final outcome of the image.

As digital photography has become so advanced the need for transparency film (particularly in the studio environment) has diminished very rapidly. Now images can be viewed directly and, more to the point, almost immediately. But there are still a number of very high quality transparency films available (though not all film **emulsions** are still available in all film formats).

Nowadays, the majority of film users prefer to shoot colour negative film alongside their black and white. Like black and white, once exposed, a negative image forms on the film and this is fixed during the **development process**. The fact that negative film can be more forgiving, having increased latitude for under and overexposure, keeps it popular. In fact, many photographers who are involved in digital images still shoot on film and scan the negative before continuing work on the image digitally.

The range of negative films available has been streamlined in the last few years and, like transparency, some are only available in certain sizes.

positive a type of photographic film used for colour slides and transparencies. The lights, shades and colours are a true representation of the original object
negative a widely used term for both black-and-white and colour photography film. The emulsion captures light in opposite wavelengths from the subject and, once processed, the image tones are reversed, thus the term negative
emulsions the coating of light-sensitive material used in the production of photographic film and papers
development process the chemical treatment of film resulting in the creation of a visible image

The construction of colour film

Before examining some specific emulsions and manufacturers a greater understanding of the construction of colour film must be gained.

Both black-and-white and colour film have a similar basic construction. A thin strip of plastic is coated with light-sensitive emulsion in either one layer (for black-and-white film) or various layers (for colour film). In colour film, each layer has silver salts suspended in it and each of these records a different component of the visible spectrum. This is usually a blue-sensitive layer on the top, followed by a green-sensitive layer and then, lastly, a red-sensitive layer. Fuji's four-colour film, however, uses red, green, blue and cyan (the reasons and methodology for this will be discussed in a later chapter with regard to printing).

During development, chemicals known as **dye couplers**, which are embedded in the layers, react with the developing chemicals to form coloured dyes – a **chromogenic** process. The silver **halides** are then bleached out to reveal a specific colour and the negative image is formed. When viewed together, these three (or four, in the case of Fuji's four-colour film) separate coloured images combine to form a full-colour image, or rather, a full-colour negative image.

Unlike black-and-white film, which can be machine- or hand-processed using a variety of developers to produce different types of negative, colour transparency (**E6**) and negative (**C-41**) processing is much more of a mechanical procedure. In general, because it is so critical that the chemistry is spot on (or at least carefully analysed to ensure consistency) and kept at an accurate temperature, many photographers prefer to delegate film processing to specialist labs.

'Everyone has a photographic memory but not everyone has film.'
Unknown

dye couplers chemicals that form visible dyes when they react with processing chemistry

chromogenic a process where traditional silver is first formed and then replaced by coloured dyes. Each layer of emulsion incorporates coloured dye couplers. Once processed, the dye adheres to areas where the silver is still present

halides compounds of a halogen with another element or group. These are suspended in each layer of film and are later bleached out to reveal the captured image

E6 standard processing chemistry for positive colour reversal (slide) film

C-41 the standard colour negative film processing chemistry

Woods, Wanstead (below and facing page)

The following two images show the difference in colour and contrast that can be achieved using different types of film.

Photographer: Steve Macleod.

Technical summary: Kodak Portra 160nc (natural colour) film (below) and 160vc (vivid colour) film (opposite).

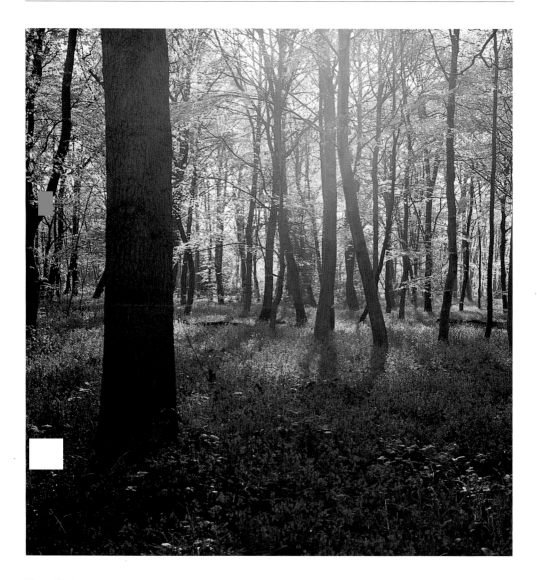

Natural colour

Shot on Kodak Portra 160nc (natural colour) film and processed normally, the colour and contrast on this image is more subtle and dull than its vc (vivid colour) comparison opposite.

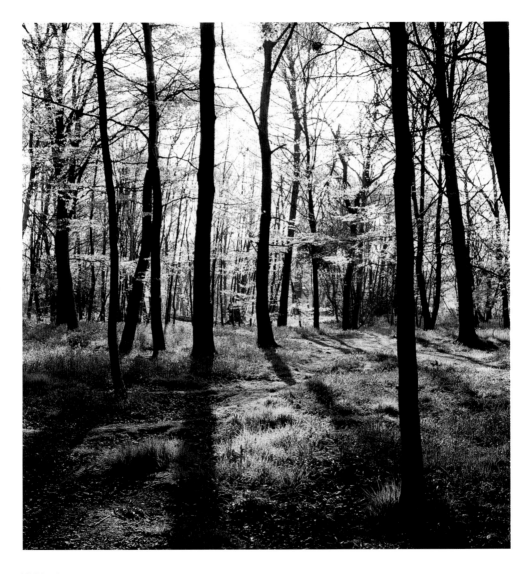

Vivid colour

This was shot at the same time as the image opposite, but on Kodak 160vc (vivid colour) film and processed at +1/2, thus showing how the choice of film can affect the quality and mood of images.

The colour wheel

When viewing a colour negative it can be quite difficult to assess density and exposure. Not only are the colours – obviously – in negative, reversed form, but also there is the presence of the orange dye mask that covers the whole of the film base, which is used to help achieve accurate colour when printing (though the colour itself is filtered out).

When printing and assessing colour negatives, photographers use an RGB colour wheel, a disc upon which colours and their complements (the corresponding colour on the negative) are presented. It is useful to be familiar with colour opposites and to try to build up knowledge of colour in order that the printing process can become more controlled.

The wheel is made up of the three basic colours – red, green and blue – and the results obtained when they are mixed together. As can be seen, the wheel is split into two halves, one comprising 'cooler' hues and the other comprising warmer colours; as the colours come together they begin to merge or harmonise. Viewing colour is a subjective and individual trait in all of us, yet all would agree that certain colours are more comfortable to view both on their own and in combination. For example, an image that is made up of a single predominant or monochrome colour and neutral shades of others will appear more harmonious, whereas if we start to add several colours together – bright reds and greens or blues and oranges – then the image will appear more vivid and less harmonious.

When talking about strong colours or pale shades, we inevitably start talking about colour saturation. So what is colour saturation? This is a term that originated from the textile dyeing industry where various amounts of a particular dye would be used to colour neutral cloth. The term has made the transition to the photographic world and determines how much colour is in the image.

A highly saturated colour has intense and vivid colouration whereas in a less saturated colour, the basic monochrome elements of the image have a greater bearing. If the subject is light, it will contain pastel colours but if darker, it will appear more drab. Saturated colours have a direct impact on images and can be particularly effective when used in strong lighting. More muted colours, such as a primary colour mixed with grey, brown, black or white, will add subtlety and balance to an image and in a softer light will create a more gentle atmosphere.

Adding black or white to primary colours will also mean that it will progressively become desaturated. This is a technique often used when flashing a print; introducing a desaturated colour will flatten and subdue the overall feel of the image.

Red

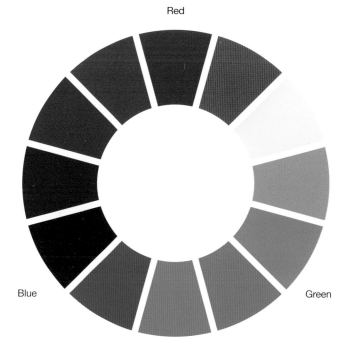

Blue

Green

The RGB colour wheel

This colour wheel is much more relevant to today's digital age. Red, green and blue are the three fundamental colours, from which all the others can be mixed. Each colour on the wheel is created by mixing the two colours adjacent to it on the wheel. Each colour has a complement – the colour opposite it on the wheel.

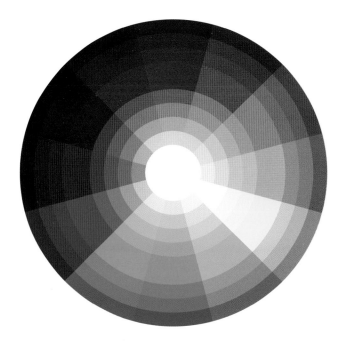

RGB colour wheel showing saturation

Towards the centre of the wheel, more white is added, creating less saturated colours, and as more black is added towards the outside of the wheel, colours become more saturated. Notice also that the colours on the above half of the wheel are much warmer than those on the cooler, lower half.

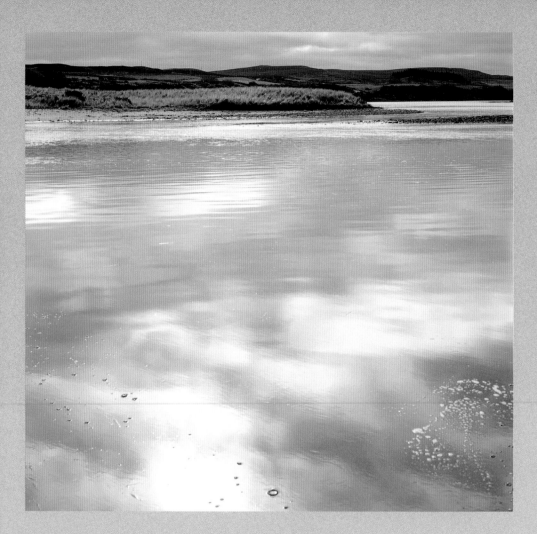

Original image

Here the colours are quite muted and predominantly cyan in range.

Calm Water, Melvich Beach (above and facing page)

The three images shown here illustrate the effects that can be achieved by adding or subtracting colour.

Photographer: Steve Macleod.

Technical summary: Rolleiflex 2.8GX, Kodak Portra 160nc (natural colour) film, f8 at 1/60th sec exposure, printed on Kodak Endura glossy paper.

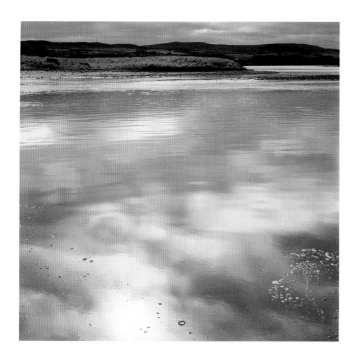

With increased cyan
Here, the cyan content has been increased, creating a more vibrant print.

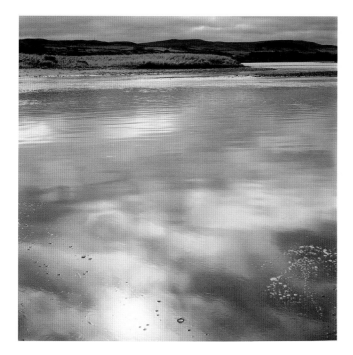

With decreased magenta and yellow
This print was flashed for one second with decreased yellow and magenta, resulting in a more muted print with less saturated colour, creating a calmer image.

Film emulsions and manufacturers

Professional photographers get to know their films very well. They will often gain such a thorough understanding of an emulsion that they will know precisely how much exposure is needed (and whether this is above or below that recommended by the manufacturer) and also any **filtration** they may need to apply to the image to get the colour rendition they desire spot on. Here are some of the more popular emulsions available today:

Fujifilm

Fujifilm – one of the companies that has spearheaded the digital revolution – has been a stalwart in the production and development of traditional film emulsions too.

There are currently two brands in use professionally: Fujicolor Superia Reala (ISO 160; 400 and 800 speeds) for negative and Fujichrome Velvia, Astia (ISO 100) and Provia (ISO 100; 400), for transparency. Velvia is one of those legendary films famed for its low speed (initially ISO 50). It delivered transparencies of unrivalled colour saturation and virtually no **grain**. Fuji followed this up with Astia, a complementary emulsion that was very well suited to the tones required for first-rate portrait photography.

The warm Velvia not withstanding, Fuji films are characteristically colder and bluer in tone than Kodak films. This is particularly true of those films that use cyan as well as blue, red and green. For more information, specs can be downloaded from <www2.fujifilm.co.uk>.

Kodak

Warmer in colour than Fuji films, Kodak still offer a broad range of film, despite their increasing dependence on digital imaging. With regard to negative film there is the Elite range for general use or the more popular (and professional) Portra range. This comes in nc (natural colour) or vc (vivid colour) variants (the difference between these can be seen on pp.38–39).

These films employ the Kodak T-Grain technology and are available in speeds of ISO 160, 400 and 800. There is also a tungsten balanced film (suitable for use in **tungsten lighting** situations) with a sensitivity of ISO 100. A recent adaptation of Kodak films – the addition of a new digital ICE Technology coating – has also allowed for an improved quality in the scanning of processed film. This very clearly acknowledges that many photographers still prefer to shoot in film and then scan images in.

For transparencies, Kodak offer the Elitechrome range available in ISO 100, 200 and 400 speeds. More information can be found on the Kodak website, <www.kodak.com>.

Exposure and metering

As previously discussed, film needs to be accurately exposed to deliver its very best. This is particularly true of transparency film, which has very little latitude. Even so, some photographers take even greater precautions.

Test clips

It is common for professional photographers to bulk-buy their film and to ensure it is all of the same batch. Then they will take a film (or a part of a film) and shoot some test exposures. In this way they can assess, when this test clip is processed, whether the rated speed of the film is accurate or not. Often a single batch may be as much as one third of a stop away from its nominal **ISO rating**, so where precision is essential a test clip is shot.

Exposure bracketing

Even when the precise speed of a film – or batch of films – has been established, it may not be possible to be certain about the exposure. Where there is any doubt, photographers tend to bracket their exposure. This involves shooting one exposure at the setting that the camera determines as 'correct' and then one at, say, a **stop** over and a stop under. This is essentially over and underexposing by a single stop. For transparency film, the photographer may shoot multiple shots over and under the determined exposure, varying each by as little as 1/3 stop. Some cameras include an autobracketing feature, which also allows the user to shoot a whole set of bracketed exposures in one go.

'I find the blend of technique and creativity fascinating, sometimes frustrating, other times rewarding, but always very therapeutic.'
Thomas Folke Andersen

filtration the process whereby the amount of coloured light emitted by the enlarger is controlled

grain the particles of silver that make up film emulsion, equivalent to noise in digital imaging

tungsten lighting a glowing electric light bulb with a tungsten metal filament. Its effect can be seen and judged, unlike flash

ISO rating International Standards Organisation: in photography, used to denote the sensitivity of film and the equivalent sensitivity of an image sensor. Higher numbers indicate higher sensitivity. This rating has superseded the previous (and identically scaled) ASA rating

bracketing a method of establishing the correct exposure by taking several photographs with more or less exposure each time

stop also f-stop, a standardised measure of the opening of a lens aperture. Each subsequent f-stop (when numerically increasing) represents an aperture one half of the previous (e.g. f2, f2.8, f4, f5.6)

Winter Trees, Wanstead, London (below and facing page)

The two images shown here illustrate the difference between Fuji and Kodak films.

Photographer: Steve Macleod.

Technical summary: Not available.

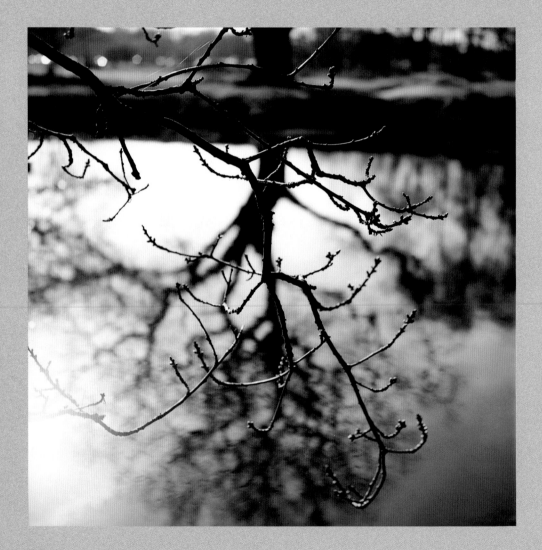

Fuji

Shot on Fuji Reala 160 colour film, this image has a much colder colour cast than a Kodak equivalent.

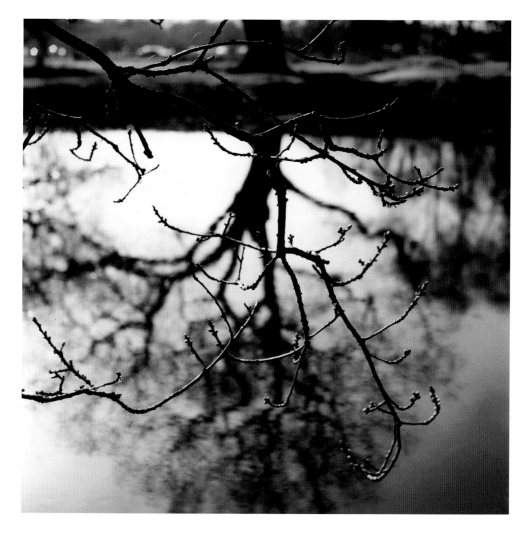

Kodak

Shot on Kodak Portra 160nc (natural colour) film, this print is much warmer than its comparison opposite.

Film processing

Once a roll (or rolls) of film has been shot, it must be removed from the camera and tuned into something that can be viewed. This means either viewing the processed roll of transparencies or producing a contact sheet from a film's worth of negatives.

It is possible for the photographer to process their own colour film, but in general, it is easier to delegate this to a specialist lab. Often this is on the basis that the chemicals used in the process have a limited shelf life (more so when diluted and made up) and they are often suited to batches (rather than single rolls) of film. There is also the risk that, because timings and temperatures are so critical (especially with slide film) that the margins for error are slight.

However, it is still very useful for the photographer to have knowledge of the basic principles involved in this stage and how they differ between positive and negative film: the processes for each are rather different.

Processing slide film

Most slide film is processed to a standard method known as E6. Originally devised by Kodak, now virtually all everyday slide films use the same processing chemistry. This uses simple chemicals and the only equipment needed is the same simple kit that might be used for black-and-white processing. The process is consistent and (again generally) you can process several different films at one go.

There are eight major steps involved in the processing of colour slide film:

1. First developer: six minutes at 38 degrees. This uses a black-and-white developer to form a black-and-white negative silver image in each of the three layers in the film. This is a critical stage because if the temperature or timings are off, the contrast can be adversely affected.
2. First wash: two minutes at 38 degrees. A stop bath or plain water wash.
3. Reversal stage: two minutes at 36–39 degrees. This is also called the fogging bath. It prepares the film for the colour developer and involves a chemical reversal agent (essential for producing a reversed image – that is a negative of the negative, or a positive) being absorbed into the emulsion ready for being acted upon by the colour developer.
4. Colour developer: six minutes at 36–38 degrees. During this stage, which is chemically complex, the reversed image is produced.
5. Pre-bleach: two minutes at 32–39 degrees. This is an intermediate stage that features a preservative for the dyes, and conditions the film to make it receptive to the following bleach stage.
6. Bleach: six minutes at 33–39 degrees. The bleach bath converts the metallic silver in the film emulsion into silver bromide.
7. Fixer and optional second fix: four minutes at 33–39 degrees. Fixes the film and removes unwanted chemicals and silver compounds.
8. Final wash: four minutes at 33–39 degrees.

Processing negative film

The corresponding process to slide film's E6 is C-41. Again, this has become something of a global chemistry (and it allows high street minilabs to process all types of negative film on the same equipment) although the chemistries produced by different companies do tend to vary slightly.

This simple, three-stage process involves:

1. Developing a film in a developer known as CD-4, which is designed to create the dye and the silver images in the film.
2. After the development the film is placed in a stop bath (a mildly acidic bath, using acetic acid, that counters the alkaline nature of the developer).
3. A combined bleach fix. This dissolves out the silver produced by the developer along with any silver halide that is undeveloped.

Drying

Once the slide or negative film has been developed, it is important that it is properly dried. When it first emerges from the processing tank the film emulsion will be soft and often has a translucent, milky appearance. At this stage is will be susceptible to physical damage (the emulsion can easily be scraped from the backing if it encounters a sharp object – even a fingernail). It is also very sticky. If there is dirt or dust in the air it will be prone to stick to the surface and, when dry, will prove impossible to remove.

Unless working in clean room conditions that are the preserve of electronics labs (and which are very costly to maintain), it will be possible to wholly avoid the effects of dust in the air. Consequently, it is important to ensure that the level of this ingress is as small as possible. Keep all film away from obvious areas of dust (including carpeted rooms and soft furnishing) that will exacerbate problems. In a domestic environment a bathroom is a good compromise. Consider, when anticipating a large amount of processing work, a drying cabinet. This is a reasonably dust-tight environment that can also optimise the drying speed (drying too fast can also compromise the emulsion).

Producing a contact sheet

The starting point for colour printing is often the contact sheet. This is a straight print – with no enlargement – of all the frames on a film. It can provide indications of sharpness, composition, density and, of course, colour saturation. It will also act as a future reference when archiving negatives, where cropping and exposure notes can be written on to the contact sheet.

Unlike in a black-and-white darkroom, colour printing is performed in complete darkness. This is essential because, unlike black-and-white paper, which is insensitive to the colour used in a safelight, colour paper is sensitive to all spectral sensitivity. The smallest amount of light will fog the paper. Colour printing is also a more mechanical process than black and white. Paper is processed through a roller transport RA-4 processor, a totally enclosed, start-to-finish

processing system that requires no intervention on the user's part. **RA-4** is a name that was invented by Kodak and has since been adopted as an industry standard for processing colour paper. The method is such that exposed paper is fed into the machine in complete darkness and then passed via roller transport through the different processing chemistry tanks. It emerges dry at the other end.

The easiest way to make a contact sheet is to lay the photographic paper and negatives out and expose them under the enlarger with enough light to cover the whole surface area of the paper. It is recommended that the enlarger height and contrast filtration are standardised so that contacting can become a measure of how thin or dense the negatives are compared to other material that has been shot. Most photographers have the enlarger head set at a predetermined height, with an average filtration set at 50M, 90Y and 0C.

Contact print frames can be obtained from most photographic outlets and they make the production of contact sheets much simpler. However, many photographers improvise with a piece of glass taped to the enlarger baseboard. The negatives need to be sandwiched – emulsion side down – between the glass and the paper – emulsion side up. It is easier to attach the negatives or transparencies to the glass first.

A timed **test strip**, such as that shown on p.71, will provide varying densities to choose from, and will also enable the photographer to build a mental picture of how what was shot will compare to how the print will look.

A test sheet is made by exposing the negative in increments of five seconds with the paper processed in a normal manner. The white light in the darkroom can be switched on after the print has been in the fixer tray for 30 seconds. Once the optimum exposure has been judged, a full sheet can be exposed and the process continued.

It is usual to find that different frames will demand different exposures and with practice it will be possible to learn how to block or flag frames on the contact sheet in order to provide a balanced final contact sheet. This will enable better image composition assessment; this is the first stage in visualising images as well as checking for more mundane technical issues, such as sharpness and exposure.

After processing, always label and store contact sheets with your negatives, building an archive that has reference points for future use. One of the most time-consuming tasks in the laboratory is sourcing negatives and frames on the negative sheets; a contact sheet effectively aids that process and makes it much easier to locate the right image.

RA-4 a common term to describe the processing of colour papers post-exposure

test strip a strip of print where the negative is exposed for varying amounts of time in order to assess exposure density and colour balance

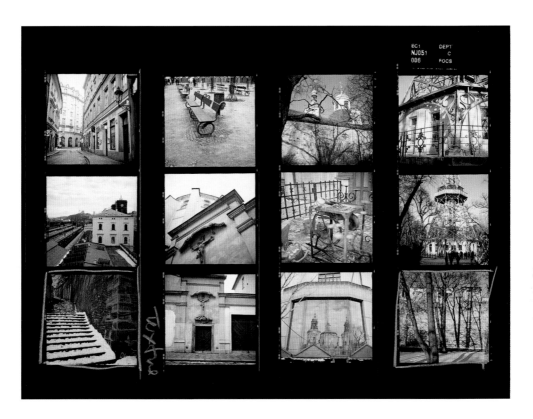

Colour contact sheet

The contact sheet is very useful tool when it comes to showing others your work and discussing a brief about printing. It is often the first time a client gets to see what it is they are paying for, so well exposed and presented contacts can create the right impression of what is to follow.

Working with digital images

This section will examine the processes involved when working with digital image files.
An initial look at the images that are recorded on a digital camera will ensure a greater
understanding of the methods used to scan different media to produce digital image files.

File formats

Commonly, a digital camera's sensor is exposed to a single passage of light through the lens,
in much the same way that film is exposed to light in the camera during a single exposure.
This sensor may be a **CCD** mosaic style or **CMOS** image sensor. These are overlaid with a
special coloured filter, called a Bayer Filter, which allows adjacent **pixels** to record different
colour information, as well as the light level information recorded by all pixels. The **data** that,
following an exposure, is extracted from the sensor needs to be saved in a way that can
subsequently be read and used to create images. The way in which image data is stored
can vary according to the photographer's needs to retain faithful information or store as
many images as possible. Hence digital cameras and **software** will make use of a variety
of file formats.

RAW: This format will provide the optimum image file as it retains all the data originally
recorded on the image sensor. The size of files of this format tend to be large because the
data is not compressed in any way (as it is in some other file formats). However, this also
means there is no compromise in image quality. The image is unprocessed and contains pixel
data that combines a mosaic of red, green and blue values so additional software must be
used in order to convert the image into **RGB** format so that can be viewed and, ultimately,
manipulated. Unfortunately, there is no standard for the RAW format so each camera
manufacturer that offers the format has tended to go its own way. Most software applications,
however, will be able to decode the data to reveal the image.

Firmware or software embedded in the camera will assess the raw data and work out what
to include in the image, though this is very basic and additional software plug-ins are required
to set the final colour balance, precise exposure and other parameters necessary to produce
a perfect image.

JPEG: The most common format for most digital cameras even though it compresses files
by discarding data. It does this by analysing which parts of the image would not be unduly
compromised if data was discarded, but if the image is compressed too much, artefacts
appear. This is known as a **lossy compression** format. Also, the more times an image is
compressed and decompressed, the more the quality will degrade. This format is popular
especially with cheaper digital cameras because, due to **compression**, more images can be
stored on a memory card.

TIFF: The Tagged Image File Format is often seen as a good compromise. It is a widely used format and is popular throughout the industry. It is widely supported by Photoshop and although the file sizes are larger than jpegs the quality is substantially better.

GIF: Primarily used in the web graphics industry and uses only 256 colours.

PICT: A Macintosh-based format that can accommodate compression and is good for images that use predominantly plain background colours.

BMP: A Windows-based system that supports large and uncompressed files, commonly 24- or 32-**bit** colour images, though using lossless compression will provide compact file sizes of 4- and 8-bit size.

PDF: This is the common Portable Document Format which is mostly used for document layout. It is often used for downloadable files, magazine and book publishing.

'It's not about moving pixels, it's about pictures that move us.'
John Weiss

CCD charge-coupled device, a chip that converts light into electrical signals

CMOS an image sensor using alternative technology to the CCD. It is preferred for some situations because of its low power consumption

pixels (contraction of picture element) the individual elements that comprise an image sensor and, consequently, a digital image

data the information on which a computer operates, which can be stored or transmitted

software the programmes and operating systems used by a computer

RGB red, green and blue, the colours used for displaying an image on a screen. Each colour has 256 shades and can combine to create 16.7 million different colours

firmware permanent software programmed into a computer

lossy compression a type of file compression that compresses the file to a much greater degree than with lossless compression. It does this by discarding some of the data. When the image is restored there is a drop in quality proportional to the amount of compression

compression a way of storing a digital image file by first compressing the data to allow more images to be stored on a memory card

bit a binary unit that is the smallest unit of information used by computers

Memory cards

Digital cameras – save for the few that have on-board memory only or those high-end models that connect directly to a computer – use memory cards for their image storage. Although there are many different types and styles available (most of which are incompatible) it is easy to think of these as the digital equivalent of film. You fill a card with images, just like film. You fill a card and you insert another. There are two big differences though. Once a memory card is full, the images can be downloaded to a computer and the card can then be reused. More significantly, with regard to a parallel with film, the memory card has no bearing whatsoever on the type or quality of image. Unlike film, which is selected on account of the unique properties it can be expected to give to the images shot, an image stored on a memory card will be identical to that stored on any other card.

Today, memory cards are available in very high capacities. Whereas once, only a handful of TIFF or RAW images could be stored on a single card (hence the importance of JPEG files, capable of much greater storage numbers) cards capable of storing hundreds of high-quality images are now available. Photographers however, often tend to avoid the highest capacity cards because when a card fails (although this is, fortunately, rare), if it is the only card used on an assignment, it will be catastrophic. If, however, it is one of several used on an assignment it will merely be annoying.

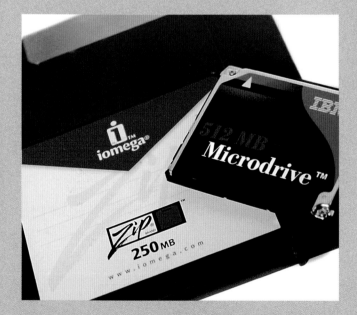

Memory cards
Memory cards allow cameras to store images much as film does on an analogue camera.

File organisation and management

As seen at the beginning of this chapter, the next stage in the digital photography process is not manipulating the downloaded images, but rather organising and managing them. Digital photography, with its limited use of consumables, positively encourages the photographer to shoot as many images as possible. This is obviously a good thing, but it does mean that the computer could, very quickly, fill with images. It is important to make sure that all images can be easily tracked all of the time. When it comes to working on images it makes no sense to spend much of the time, otherwise spent on editing work, hunting for an image amongst hundreds – or thousands – of others.

As with the storing of negatives, there will come a point – very quickly – when the photographer will have to create and design a system of filing that enables easy and accurate recall of digital files. The good news is that most cameras come with a bundle of software that will include basic management programs used for transferring images to a hard drive. The emphasis here is on 'simple' and these are often too much so. These will rarely offer any more than a computer's operating system offers, placing image files in discrete folders, distinguished only by different titles or date stamps.

Fortunately there are currently several manufacturers of more extensive asset management or DPM (digital photo management) programs that provide an expanded and more meaningful way of managing and cataloguing files. These systems also allow the user to work with additional computer drives and will even show which files have been backed up or copied to DVD or CD.

As an aside, it is worth noting that as the number of images stored on a computer grows, they are each assigned unique codes that relate to the data being stored. This is merely a way of uniquely naming the file and is designed purely so that the computer knows what has been downloaded and where it is. This file name will contain nothing that is meaningful about the contents of the file or anything that will be useful to the user in retrieving that file.

Photoshop file browser

File browsers allow the user to locate images stored on a computer quickly and easily.

In order to locate and retrieve files easily, it is a good idea to caption files and apply keywords to them so that they can be easily searched for.

Programmes such as iPhoto (Macintosh only) and the file browser provided with Adobe's Photoshop provide good basic methods of file management, but something more comprehensive will be needed for a very extensive library. It is wise to use one of these applications immediately to avoid having to port images across later and – possibly – reconfigure them all with new keywords and captions.

Cataloguing and managing programmes to audition include Extensis' Portfolio and ACDSee. Both these offer expanded options for tagging images and provide easy ways to locate them later. These applications also tend to be widely used, which makes it easy to exchange and share material. For example, if a client or an agent also uses Portfolio, it makes sense for the photographer to send them a Portfolio catalogue in the certain knowledge that they will be able to review the contents.

Both ACDSee and Extensis Portfolio also offer the ability to create slide shows and to create dedicated folders for specific image types.

It is important to find a system of filing and organising that works both on a mechanical level, efficiently storing images when **downloading** (and allowing the user to swiftly **tag** and keyword them appropriately) and which works with the user's type of photography. Furthermore, if considering syndicating work via an agency or image library, it is important that the file meets the technical specification of that organisation. Remember that, in this case, it is crucial to apply the right keywords to the image. If potential customers cannot shortlist images using keywords, it doesn't matter how good the photographs might be, no one will be able to see them to judge!

If, on the other hand, you are building a project over time it is important that your project albums are accessible and the same consideration must be taken when constructing portfolios or slide shows: you have to be able to locate the folder and to quickly add and subtract images with continuity wherever located.

downloading the process of transferring data from a peripheral to a computer
tag images can be assigned a unique keyword through which they can be easily identified

Workflow applications

In recent years Adobe has bolstered its Photoshop product by introducing a new application that can run in parallel or as an adjunct to the main program. Called Photoshop Lightroom, this is designed as both an image management and a bulk image processing application. Apple has its own version called Aperture. Both these applications allow for fast file transfers, internal management of images and the application of similar corrections to a wide selection of common images at once. These applications have become particularly popular now that the RAW image file format is so popular. Because getting the best from a RAW image involves a degree of pre-manipulative work, the ability to apply modifications to one image and then apply the same to all those images shot in the same session is very much welcomed.

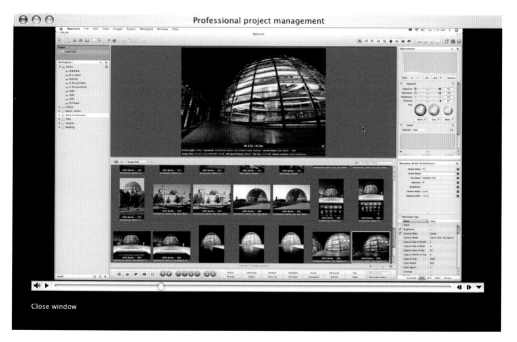

Aperture (above)

This allows the user to store relevant details about the file selected.

File Info pop-up panel (left)

Detailed information can be stored here for future reference.

Scanning film and negative images

Apart from using digital files direct from the camera, photographers also acquire files for post-production by scanning from film or paper original. It may be very contentious but, while digital cameras are still in their adolescence, many say that scanning film is still the best method of producing a digital file. This was, after all, the rationale for Kodak introducing finer grains and a protective overcoat to the emulsion of the Portra range of films.

As was touched upon earlier, flatbed and desktop scanners use a moving three-colour RGB CCD sensor for scanning an original. As this moves across the image being scanned it slowly builds up a complete image. It is much like a digital camera exposing only one row of pixels at a time and progressively building up an image. Of course, this method would not be suitable for moving objects, but it is fine for achieving high-resolution images from a print or negative.

Some flatbed scanners also come with a transparency attachment that allows for the scanning of negative or transparency up to 10" x 8". This is a useful addition for those photographers that may have a few transparencies to scan but not a sufficient number to justify the investment in a dedicated film scanner. These attachments (which are sometimes built in, and on other models are interchanged with the standard lid) work by disabling the illumination used for lighting prints and flat artwork. The device then lights the back of the transparencies – using a separate light system – during the scan.

Author's tip

When purchasing a desktop scanner, look not only at the maximum resolution it offers, but also the 'dynamic' range. It is these two parameters that, together, will define the efficiency of the scanner in producing scans. The 'dynamic range', often abbreviated to just 'D', is a measure of the brightness range that the scanner can accommodate from the darkest black to the brightest white. Without going into the technicalities, the higher the 'D' factor, the better the dynamic range and the better the scanned image will be.

Resolution is important when obtaining a good scan. The higher the resolution, the better the scan. Take care when checking the resolution of a scanner. Some scanners will quote a resolution and also an **optical resolution**. It is the optical resolution that is important; the other resolution (sometimes denoted as **interpolated resolution**) is irrelevant because a scanner can only resolve as far as the optical resolution. Resolutions above this are actually created by mathematical processes that add extra pixels – interpolated pixels – that are not based on real data but rather on an average of adjacent pixel values.

In fact, a resolution of 600ppi (pixels per inch) is sufficient for prints (and 300dpi may be okay) or 4,800ppi for film scans. Anything significantly over this will be overkill and can, on some films and papers, do nothing more that resolve detail below the limiting scale of the grain.

There are, of course, exceptions to every rule. The Hasselblad Flextight series film of scanners has an excellent operating system and the new X5 version offers up to 8,000ppi from a 35mm original. Not only that, but the resulting image files also have a very good dynamic range. Being upright, they also take up minimal space when compared with other high scanners.

An alternative form of scanner used in professional labs is the drum scanner. Here the original object, film or paper is mounted onto the drum held between sheets of acetate. The drum rotates at high speed and the original media pass in front of the imaging optics. These then transfer the brightness and colour information to three RGB-matched PMTs. Very high resolutions can be achieved with these scanners, typically between 8,000–14,000ppi.

Dust removal
When using a scanner there are certain issues that come to the fore. The first to be considered is dust. No matter how clean the working practices, original images can attract dirt and dust specks. These may be invisible on casual inspection but when scanned at high resolution, they become all too obvious. Many scanners have a dust removal facility built into the system. This does not, however, clean the negatives, slides or prints, but rather electronically detects the small image details that correspond to dust flecks and removes them from the digital file. This option must be used with great care, as small, delicate areas of the image may be blended away at the same time as actual dust particles. This can result in an overall softening of the image.

There are optical solutions for the elimination of dust too. The Flextight scanner range now offers a light condenser feature that will eliminate small dust particles only, which is in addition to the dust removal facility.

Dust removal packages, such as Digital ICE and Canon's own FARE™ (Film Automatic Retouching and Enhancement), operate by making a second pass over the original with an infrared beam. This maps a three-dimensional sample of the film plane, so that dust particles can be identified from the actual film surface and these are then blended by a separate software programme.

resolution the amount of detail that can be resolved in an image. It is determined by the resolving power of the lens (i.e. how sharp the lens is), the grain structure of film or the number of pixels that comprise the image. Higher resolution images contain more detail and can be enlarged further when printing without the grain or pixel nature becoming visible
optical resolution the actual resolution, not interpolated or digital resolution
interpolated resolution the resolution that can be obtained by cloning intermediate pixel values in order to mathematically increase the number of pixels in an image

Dust removal: before
Close up of the digital file before the Dust & Scratches option has been applied.

Dust removal: after
Close up of the image after removal of Dust & Scratches filter. The result is a much softer-looking image.

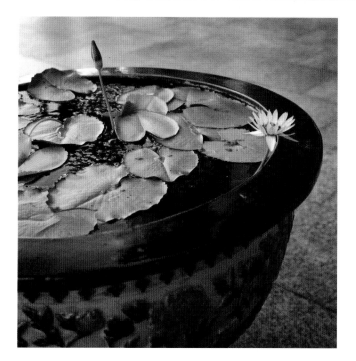

Scan with Unsharp Mask filter applied

Here the image was scanned with the Unsharp Mask filter switched on. This method is not recommended for best results.

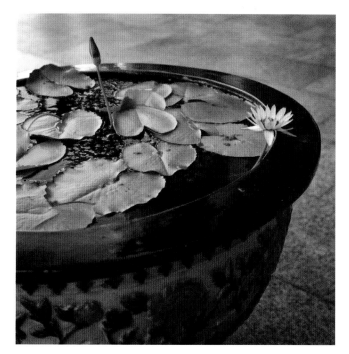

Scan without Unsharp Mask filter

Instead, it is best to scan the image without the filter (producing a softer image) and then apply sharpening techniques at the post-production stage.

Modifying sharpness
As with dust removal facilities, all scanners come with a software feature for enhancing image sharpness during the scanning process. This is known as 'unsharp masking'. Unsharp masking was a technique whereby a soft negative version of the image would be sandwiched in contact with the positive original, resulting in improved edge definition and a much sharper-looking image. The software version emulates the effect of this image sandwich. As can be seen from the images on p.61, implementation of this filter can be quite crude in the scanner and, unless there is good reason to do otherwise, it is best to leave it switched off when scanning and apply sharpening to the (almost) finished image, post-manipulation.

The Unsharp Mask in Photoshop works by increasing the pixel contrast for areas where adjacent pixels have a value greater than that specified by the threshold. To avoid creating unwanted contrast, three options help to control the effect of the filter on the final image:

'Amount' controls how much the contrast of the adjacent pixels within the threshold are increased, the higher the percentage the greater the effect.

'Radius' determines how far the filter searches for differences between the pixels. Best results are usually achieved when this is set at between one and two pixels.

'Threshold' determines how different pixels' values should be before they are eliminated.

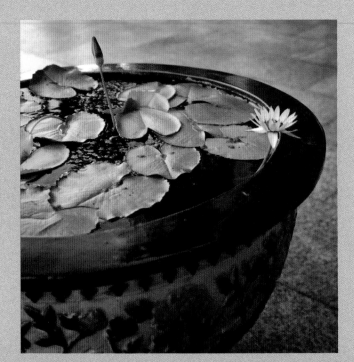

Amount
Here the amount of sharpening is set at 500 per cent.

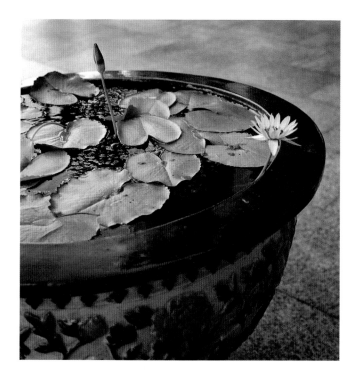

Threshold

Here the percentage amount is minimum and the threshold level has been decreased, resulting in a much softer image.

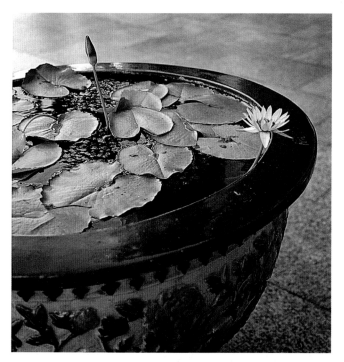

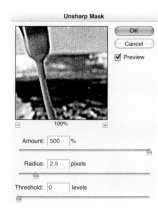

Radius

This time the actual pixel value is increased to 2.5, making the image appear much sharper. The danger here, however, is that by adding too much sharpening, the image can appear less optically sharp and more digital in feel.

Colour management

Colour management is fundamental to good post-production, whether in black and white or colour. Often in digital imaging, output prints do not share the characteristics of colour and tone that the same images displayed on screen do. The goal of colour management is to calibrate and control the working parameters of all the equipment used in post-production to ensure – as far as possible – complete consistency.

Nowadays, most manufacturers will supply ready-made colour profiles (essentially a set of rules on colour behaviour by the device) that will conform to the International Colour Consortium (ICC) format, which was established in 1993 to create a universal system. Any equipment that is used must be calibrated in accordance with a standard 'colour space' – range and extent of colours – typically RGB or CMYK. Also known as the gamut, once this colour space is established, each item of equipment will need to be calibrated to match. Most professional imaging laboratories tend to work in RGB, converting to CMYK (if required) on completion.

RGB mode

RGB is an additive model used for devices such as monitors to create and display colour. It is described as 'additive' because different amounts of the three primary colours (red, green and blue) are combined and mixed to create a wide range of colours. When equal amounts of each colour are added, a neutral grey colour will be produced and, at the highest brightness level, this will be white light.

In Photoshop the three channels – red, green and blue – combine equally to produce 24-bit colours, with the capacity to create 16.7 million colour combinations. An 8-bit number will define a colour in a single channel. This is a digital code represented by eight 1s or 0s. The RGB colours that are used are determined by how the equipment is calibrated and profiled. All images used in Photoshop will be assigned one or more channel, depending on which colour model is being used.

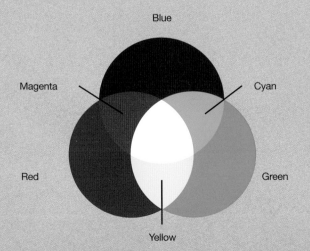

Blue

Magenta

Cyan

Red

Green

Yellow

Additive colour (RGB)

This diagram shows the additive primaries. Where red and green overlap, yellow is created. Where red and blue overlap, magenta is created and cyan is created where blue and green overlap. These secondary colours are the subtractive primaries. Each additive primary represents a component of white, so where all three colours overlap, white is produced.

CMYK mode

The alternative CMYK mode is a subtractive method based on ink and dye media and is used in the commercial printing industry for books and magazines. All images intended for print, regardless of whether they are created in RGB or CMYK, will always be converted to CMYK for printing.

CMYK is made up of the primary colours, cyan, magenta, yellow and, to ensure greater clarity, black. It describes any colour by assigning a value from 0 to 100 per cent. If all colours are present the maximum black is achieved. CMYK can display a narrower range of colours and particularly garish colours often step outside of the colour gamut or range.

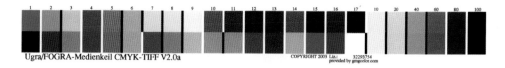

Ugra/FOGRA-Medienkeil CMYK-TIFF V2.0a COPYRIGHT 2003 Liz.: 32293754
provided by gmgcolor.com

CMYK profile strip

A control strip such as this is printed with every CMYK proof for calibration purposes in order to maintain accurate colour proofing.

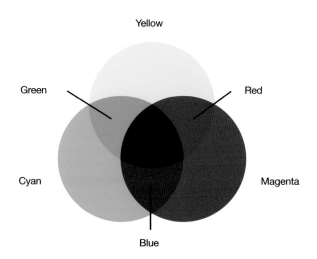

Subtractive colour (CMYK)
This diagram shows the subtractive primaries. Each of these has one of the additive primaries missing. Where two subtractive primaries overlap, only one additive primary is visible. Blue is formed where cyan and magenta overlap. Cyan and yellow overlap to produce green. Magenta and yellow combine to form red. Where all three subtractive colours overlap, black is produced because no light escapes.

Colour conversion

In recent times much of the responsibility for converting images to CMYK has been passed from the printing house back to the image maker. Many professional labs offer a proofing service where photographers can have their RGB files converted according to the publisher's profile, so that a direct match can be achieved for the specific publication.

Most people start calibrating their monitor using Adobe Gamma. This is automatically installed with Photoshop and provides a good basic screen calibration. However, a serious user should consider investing in a professional-grade colour analyser and calibrations system such as Spyder to ensure the highest quality and most consistent results.

Next, consider other equipment such as a scanner and even the camera itself. You can calibrate these by using an IT8 colour target that will provide industry-set colour and greyscale parameters. These are widely available at a modest cost, and are also available direct from Kodak, Fuji or Gretag. They come in both **transmissive** and **reflective** versions, depending on whether testing film or paper media. A reference file to match to will also be required. This is in text format and is usually provided with colour management software.

Scan the IT8 target as an RGB file with no adjustments and import it into the management folder so that it can be compared to the reference file. The software will make the comparison and any adjustments can then be saved as an **ICC colour profile** relevant to that scanner.

In practice an image can be scanned in with no adjustments and a profile can be created and applied in Photoshop. Remember to convert the image back into the colour space that you are working in (which is usually Adobe 1998) by using Image > Mode > Assign Profile. However, problems still arise, even when a system is calibrated fully. Many people make the mistake of investing in a decent printer and then buying compatible (rather than the manufacturer's own) or inferior media on which to print. Ink and paper consumables are very expensive in comparison to photographic types of media, so use material that is recommended by the manufacturer. Using the same IT8 target sheet, print off the sheet, scan it and match this to the reference file as before and make adjustments to suit. More accurately use the Colorimeter or Spectrophotometer methods, as with monitor calibration. Print out the target sheet and compare each patch to the reference file, again make the adjustments and create a profile that can be used for print.

transmissive the method of scanning slides and transparencies, where the light is transmitted through the media being scanned
reflective the method of scanning prints, where light cannot pass through the media being scanned
ICC colour profile (international colour consortium) a standard (or set of standards) for colour in cross-platform and cross-device application

IT8 target screen grab

The IT8 model is useful when manually calibrating output devices.

Cprofile

The pop-up menu for assigning a colour profile to match to.

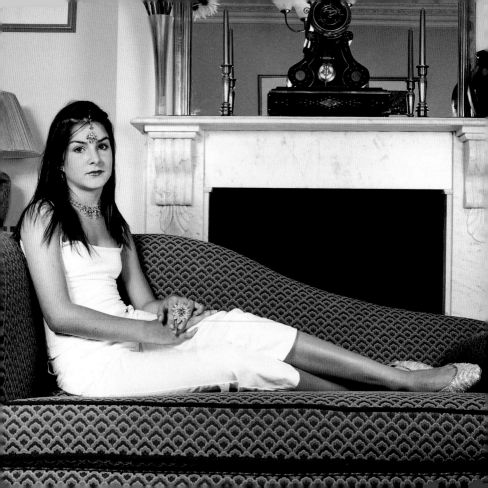

Whether working with digital images or conventional film, the ultimate aim of any photographer is to produce a great image. The image taken on a camera will contain sufficient information – data – in order to create an image, but to get even more detail from it needs a little coaxing. Fortunately both conventional and digital darkroom workers have become adept at doing this and have devised a good methodology.

Here, the processes and procedures that are necessary for making the best of a simple image are discussed. These include tests for print from film, filtration adjustments, dodging and burning, digital image-sizing, and basic colour and exposure corrections for digital images.

'Photographs that transcend but do not deny their literal situation appeal to me.'
Sam Abell

Reclining portrait (facing page)
This shot was initially used to check enlarger calibration and for balancing colour when printing.

Photographer: Michael Mardon.

Technical summary: Kodak Portra 160nc (natural colour) film, processed at normal, printed on Fujicolor Crystal Archive gloss paper.

Processing prints

Once the contact sheet has been made and the images assessed, it will be time to create some basic prints. Essentially, a basic print is one that can be used to experiment and decide what needs to be done to turn a good image into a great print.

The test sheet

When printing in colour, the enlarger will be used to control the density of the print as well as the colour balance. Colour enlargers usually have three filters (yellow, magenta and cyan) that can be brought into the path of the light. Selection controls will allow the user to vary the amount of light introduced from each filter so that the best mix can be found.

Because there are two variables involved – exposure density and colour balance – the procedure for producing a colour print differs slightly than that for black and white. Most photographers begin by setting an optimum filtration on the enlarger. These settings are usually suggested by the manufacturers of the paper that is being used. An average filtration setting, however, would be 90 yellow, 50 magenta and 0 cyan.

As colour paper is more sensitive to light (and is subsequently faster than black and white) it is usually the case that the exposures required are not as great as for black and white. If exposing for a longer time (for example, if the image will be manipulated for best effect) it will be necessary to select a smaller lens aperture. Be aware too that increased exposure on a print can affect the colour balance.

Ensure that all work surfaces are clean and that negatives are free from dust before starting work on the test sheet. Place the negative emulsion side down in the carrier.

Take the time to place the negative properly in the carrier and to ensure that the image is aligned correctly on the paper in the easel. Check that the easel blades are positioned correctly and regularly check that the enlarger is aligned and the image in focus, as knocks and drop in focus are inevitable. It is often difficult to focus a colour negative. This is because the dye structure and tone of the negative appears much finer than the coarser grain associated with black and white. This is where it can be useful to use a focusing aid such as the focus finder.

Using a full sheet of paper and a cardboard mask, expose a strip of the print for five seconds. Now move the mask and expose for another five seconds. Continue this process until the whole of the paper is uncovered. The result will be an exposed sheet where each strip has undergone five seconds more exposure than the previous.

Process the paper using the recommendations for the selected paper. If all of the strips are too light or too dark, the process will need to be repeated using more or less light as appropriate. Make a note of the exposures used on every occasion: it is important to know the precise exposure that delivers the best results. Don't worry at this stage if there is a colour cast to the images. This process is used to obtain correct exposure; filtration issues can be addressed at a later stage.

Test sheet

Test sheets are used to ascertain the amount of time that photographic paper will need to be exposed for under the enlarger. As the image shows, this exposure affects the image density and saturation. Cover up the image on the baseboard so that only a small percentage of the image can be seen, then progressively move the card in five-second increments so that a step wedge is produced.

Colour papers

Photographic paper for chemical printing is very similar to film, but totally dissimilar to inkjet printer paper. Like film, they are coated in a layer of light-sensitive emulsion, containing silver halides convert and mix with colour couplers to form colour images. Papers are either resin-coated (RC) or fibre-based (FB).

Resin-coated paper is the most commonly used paper type. The silver particles are suspended in polyethelyne, rendering the paper base virtually waterproof, so the process of washing and changing chemicals is much faster than with fibre-based paper. The chemicals in resin-coated paper serve to speed up the whole development process and fibre-based paper is much more expensive, so RC papers are a good option for novice printers.

Fibre-based papers were used as some of the very first photographic papers. The silver particles are embedded in the actual paper itself and it is not coated and sealed like RC paper (although it does have a coating of emulsion). The chemicals present in RC papers are not present in FB papers so development is much slower. However, FB papers have a much longer lifespan and are preferred by many professional photographers because they are capable of achieving much greater depth, richness,warmth and tonal range.

When selecting photographic paper, it is also important to take into account the difference between graded and multi-graded paper. Graded paper offers five grades, corresponding to the level of contrast it will produce. Grade One will produce low contrast and Grade Five will produce high contrast and a harder finish. Multi-graded paper contains several layers of emulsion that react to different colours of light. This makes it possible to create different levels of contrast on one sheet.

As with film, Kodak and Fuji are still the dominant paper manufacturers. Fuji provides the Crystal Archive range, which comes in matt, gloss and supergloss finishes. These have increased whiteness and saturated colour, the supergloss in particular, which provides prints of increased contrast and vibrant colour, although the paper base has a warmer cream base to it.

Kodak supply the Endura range of professional papers, which are discussed in more detail in the following chapter.

Author's tip

Special filter sheets can be used to make selecting the right filtration simple. These take the form of a sheet of separate filtered 'spots' that are placed on the enlarger baseboard, over a fresh sheet of paper. The paper is then exposed and processed. Spots that contain the cleanest white offer the best colour balance setting. By referring back to the original filter sheet, it is possible to see what filter values correspond to this and dial them up on the enlarger.

Filtration
Once the correct density (that is, the exposure) has been found, a filtration test must be carried
out. Before doing this take some time to assess the image produced on the test strip with
regard to colour. Is it too warm, or too cold? Is there an unacceptable colour cast? If it is hard
to visualise the colour casts on the test image it might be sensible to make an interim image,
exposing the whole negative using the optimum exposure determined with the test strip.

Remember too that for most images there is a subjective element to colour assessment.
The colour balance that one person thinks is right may be somewhat different to that which
another considers best. There is also a difference between 'best' and 'right'. The 'right' colour
balance is that which the equipment determines to be the most neutral. This may not be –
and often isn't – the setting that provides visually the best image.

In fact, it is generally found that even if all the guidelines are followed, any test print will have a
colour cast. This can take the form of a pale tint or a deep saturated hue. This is actually quite
normal as all enlargers tend to have a colour bias and the paper that is used will vary according
to batch in its precise balance. Very few first prints are perfectly balanced.

To adjust for any colour cast, a second print must be made. Photographers often prefer to
expose a new sheet of paper in quarters, without moving it from the easel, and altering the
filtration value for each quarter. This allows the photographer to make a better judgement of the
colour balance than might be achieved using discrete strips.

The colour balance in the print can be assessed with the help of the filtration diagram shown
on p.74. If the image is too cold make three more exposures with subtractions as indicated on
the right of the diagram. If the image is too warm then make three more exposures with
additions as at the left of the diagram.

Consider this example: If the basic exposure was 50Y, 90M and 0C and the colour of the
image was too warm then from the first quarter of the print, change to 60Y, 90M and 0C,
then third quarter 60Y, 100M, 0C and fourth quarter 50Y, 100M, 0C.

The diagram will help to establish which measures must be taken to correct any colour
imbalances. If the image is too warm, adding yellow or magenta (or a combination of both)
will help to help cool it down. Conversely, if it is too cold, subtracting yellow, magenta or a
combination will warm the image up.

As with exposure determinations it is essential to note down the changes in filtration as
they are tried. The filtration test will provide four varying zones on a single sheet of paper
and (hopefully!) one of those will be close to the desired effect. It is at this point that fine tuning
the filtration settings becomes difficult. Large leaps in filtration are easy to identify, but more
subtle changes not so. If none of the tests are close, it will probably be necessary to go back
to the enlarger and make further filter changes.

Ring around diagram

-2OY

-2OY -2OM +2OM

-1OY

-1OY -1OM +1OM

correct

-1OM +1OY +1OM

-2OM +1OY +2OY +2OM

+2OY

Colour ring around diagram (above and facing page)
This diagram shows how adding and subtracting amounts of cyan, magenta and yellow light into the enlarger light stream can affect the feel of an image. This is very similar to the Variations application in Photoshop.

-20Y -20M

-20Y

+20M

-10Y -10M

-10Y

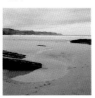

+10M

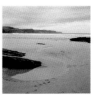

correct image

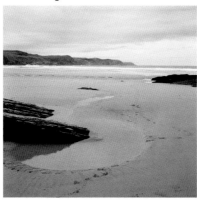

-10M

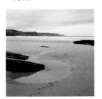

+10Y

+10Y +10M

-20M

+20Y

+20Y + 20M

Willy Lott's house, Dedham (below and facing page)

It is essential to be able to visualise how a desired image will look and then put technical knowledge into practice in order to achieve it.

Photographer: Steve Macleod.

Technical summary: Kodak 400nc (natural colour) film, printed on Kodak Endura C-type paper.

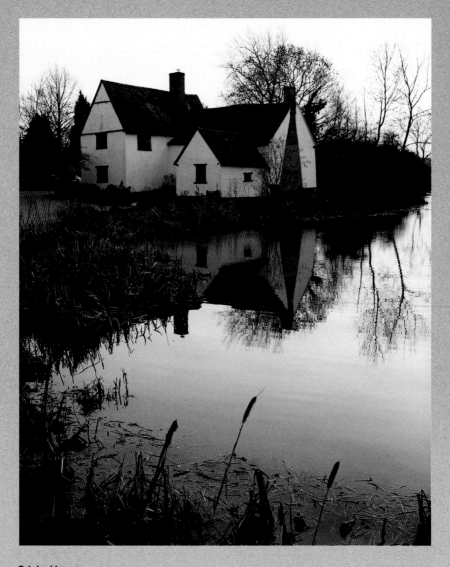

Original image

The overall tone of the original print before colour balancing has a warm and dark tone to it.

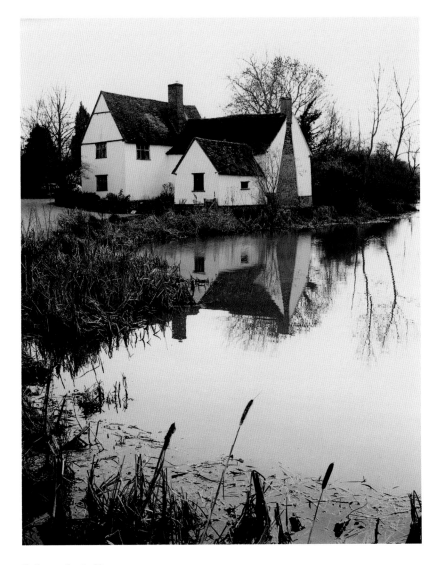

Colour-adjusted image

Here, the amount of magenta light in the light stream is increased to create a more cyan print
that is cooler in colour and feel.

Beach shades, the Gambia (below and facing page)

Adjusting the amounts of a particular colour in a photograph can alter the viewer's perception of the scene being portrayed.

Photographer: Steve Macleod.

Technical summary: Rolleiflex 2.8GX, Kodak 160vc (vivid colour) film, processed normal, printed on Kodak Endura C-type paper.

Original image

The original image is printed with a neutral tone throughout, representative of the light and colour present at the time.

With added cyan

Here the amount of cyan light is increased by five per cent, resulting in a much warmer and softer image. This is what we would expect from such a scene.

With added magenta

Here, the amount of magenta light is increased by 10 per cent, giving a colder cyan bias, which sends confusing signals to the viewer as we would normally expect warmth from an image such as this. This print was also given five per cent more exposure.

Ploughed field, Dedham, Suffolk (left)
Shot in early winter sun, the use of film here has
meant that the print accurately reflects the light
and colour shift of the seasons.
Photographer: Steve Macleod.
Technical summary: Mamiya 7MkII, Kodak Portra 400nc
(natural colour) film.

The basic print

Once the optimum exposure and filtration have been found, a basic print can be made. The idea of a basic print is to show the image as it should appear with regard to colour and exposure (although it will not necessarily be a final print). This is because the settings that have been applied so far may be a perfect average but they may not be perfect when it comes to getting the best from the image as a whole. For this, it might be necessary to further manipulate the image. Some parts of the image – normally the **shadow** areas – may need additional exposure to make them lighter and reveal more detail and some parts (for example, the **highlights**) may need less exposure. The basic print will be a useful tool for verifying which parts of the image need this specialist treatment. The techniques involved at this stage will be discussed in this section.

Dodging and burning

The camera is a very honest device. Once it has been configured with the settings that the photographer requires it will shoot images faithfully. In fact, it can often be very clinical in the way that it sees the world. Similarly, when making a print from negative the basic print is a direct representation of that original image. It is unlikely that the print will have a range of brightness that directly matches that of the paper and makes best use of the paper's contrast range. It may be that the contrast range of the image is too high for the paper. In this case an average exposure would result in the highlights being rendered without any detail and the shadow areas reduced to black and featureless dark greys. Conversely the **contrast** range of the image may be limited and could do with a boost to avoid the image becoming 'flat'.

These manipulations basically involve making adjustments to the exposure on a very local basis. Photographers and print workers call this process dodging and burning. **Dodging** some areas of the image protects them from the full exposure and **burning** others provides more light.

Skilled photographic printers tend to use their hands to shade selected parts of the image – to dodge them – or use card sheets with roughly cut holes cut in to burn in selected areas. It is also possible to get sets of special dodge and burn tools from photographic equipment suppliers that include sets of small masks attached to wires. In use these tools will tend to be kept moving, sometimes very slightly, during the exposure to ensure that no harsh (and often rather obvious) edges are left. It is also possible to vary the height of the tool from the baseboard to ensure that the edges of the tool are ill defined.

shadow the darkest part of an image and the converse of highlights. In a digital image the shadow is represented by tone 0
highlights the brightest part of an image. In a digital image it is represented by tone 225 on the tonal scale
contrast differences in colour and tone in an image
dodging exposing certain areas of a print less than others
burning exposing certain areas of a print more than others

How much additional – or less – exposure should be given to areas of prints? Those attempting their first dodging and burning exercises tend to add – or subtract – a modest amount from the overall exposure time. When the print is processed, the differences are barely perceptible. The differences in exposure need to be more profound. For example, to give part of an image a one-stop increase in effective exposure (that is, make it one stop or 1 EV lighter) the exposure time to that part of the image will need to be halved. To make an area one stop darker, the exposure time will need to be doubled. So, if the image has shadow areas that need lightening by two stops those areas will be given around one quarter the exposure of the other areas.

When dodging and burning, some basic artistic skills will need to be mastered. Though the process of allowing greater or lesser exposures to parts of the paper are mechanical, knowing how much and how far to go is a skill that needs a keen eye and a little artistic interpretation. Fortunately, as a skill, it is one that photographers have a tendency to pick up the more they attempt it.

Once these corrections have been made it is very useful to compare the finished print with the original. Because there is no 'right' and 'wrong' in dodging and burning, it is useful to do before-and-after comparisons and be objective. To get a successful and ultimately powerful print may take several attempts, but the results will be well worth the expenditure in time and resources.

Author's tip

When doing a filtration test it is possible that one or more of the zones may appear lighter than the others. This is due to the light absorption caused by the filters in the enlarger. As filtration is varied there can be an increase or decrease in the density of the filters and the amount of light that exposes through the negative to the paper. This must be compensated for when make an exposure. Essentially, if adding filter value, the exposure time must also be multiplied by a corresponding factor and, if the filter value is removed, it must be divided by the respective factor value. The table below illustrates the compensations that need to be made.

Filter factor values

Filter value	05	10	20	30	40	50
Yellow	1:0	1:1	1:1	1:1	1:1	1:1
Magenta	1:2	1:3	1:5	1:7	1:9	2:3

Room, Achvarasdale (below and facing page)

Here, the effects of dodging and burning and exposure correction can be seen.

Photographer: Steve Macleod.

Technical summary: Kodak 160nc (natural colour) film.

Original print

The fact that this image is soft adds to the energy of the print. But the image needed to portray a scene that felt hurried, abandoned and empty. The basic print was initially made to match the contact sheet; 20 seconds at f16, M50 90Y 0C.

Dodged and burned print

This time the overall exposure was increased to +30 seconds to affect the colour of the print. The increase in density meant that the image took on a colder, greyer colour cast and, by burning and vignetting the edges, the print took on a claustrophobic, uncomfortable feel.

Basic digital image manipulation

Photographers who make the transition from a traditional darkroom to the digital equivalent often feel, initially, that they are moving into an alien world where the working practices and the processes are quite unlike those to which they have become accustomed. Fortunately, they often realise, quite quickly, that although there are many differences between the two methodologies there is also a considerable level of similarity. Better still, many of the digital versions of traditional darkroom techniques are far simpler to employ.

Image sizing

When a digital image is shot – or a digital file is created from a scanned film original – an image of finite size is created. It is convenient to consider it as akin to a film negative. Because of its finite size, the size of print that can ultimately be produced is limited. When, say, a 35mm original is enlarged beyond what the format is capable of, there will become a point when the grain becomes obvious. When the same is done to a digital image the pixels that comprise the image become similarly visible.

When considering digital images, think about what the image will be used for. Unlike conventional film, which is almost always used to output prints, digital images may also be used for delivery by, or display on, the Internet. They may never make it to paper and instead always appear on a computer screen or similar display. Whatever the end use is going to be it makes good sense, in the early stages at least, to keep the image quality and the resolution at its highest, reducing it in size (as is required for web page use) only when required.

Despite the alternate presentation methods, most photographers still produce the majority of their images either for print or at a resolution that would allow the printing of high-quality images. Therefore, consideration has to be given to file size and format. For publication a file of 35-50mb is considered ample whereas for printing a large image a file of 100mb may be required.

Syndication agencies are now setting out requirements for digital images that they will accept from photographers and it is wise to become aware of these. If a file does not conform to the requirement it will not be accepted, no matter how good the subject and composition may be.

Reducing image size

Using digital techniques, the size of an image file can be altered by increasing or decreasing the number of pixels that comprise the image. If images are destined for the web, the number of pixels can be decreased. This is done by selecting Image menu > Image Size and then entering the new dimensions for the image. With the Constrain Proportions box checked, only one of the dimensions need to be changed; the other will change automatically. Images can be decreased in size as much as is required although it is always good practice to save a copy of the original file as well as the smaller version. Then, should any work need to be undertaken on the larger version again it won't be a problem; if the original image is resaved as a smaller version it will not be possible to restore it to its original size with all the original information. The reasons for this will be more closely examined in the following section.

Increasing image size

Most digital imaging experts will advise against increasing an image's size unless for very good reason. When an image file is enlarged, more and more pixels will be progressively added but it will not be possible to add more detailing. It is impossible, after all, to add more detail to an image than was there in the first place. Occasionally, though, it may be necessary to provide a client with an enlarged image. This can be done using some additional digital techniques to give the perception of a more detailed image.

Author's tip

An image file's resolution and size parameters are adjusted via the Image Size menu. In this there is a default setting called 'Resample Image'. This is automatically selected when the menu is opened. When this feature is active and the size of the image is increased or decreased, the new pixel dimension values will increase or decrease the dimensions of the image. If a new physical dimension is requested or if the resolution is altered (to alter the image size) then the pixel dimension will also change. To alter the output dimensions of an image but to leave the resolution the same, uncheck the Resample Image box.

Interpolating an image

When the pixel dimensions are adjusted (principally to make an image larger) this is known as interpolation. Image manipulation applications such as Photoshop provide several methods of achieving this, of which the most popular method is 'bicubic'. This provides the best image quality. It works by inserting new pixels and then automatically reading the values of all neighbouring pixels (in the nearest 4 x 4 neighbourhood, that is the four nearest neighbours) and calculate an average for each new pixel value. Photoshop CS now has two methods of bicubic interpolation: 'Smoother' for larger oversize prints and 'Sharper' for decreased pixel resolution.

Another method commonly used by professional imaging companies that specialise in the production of enlarged or oversized outputs (via Lambda or Lightjet equipment) is 'Fractal' interpolation. This will produce a sharper image relative to scale. This interpolation method is not provided within Photoshop (or certainly not up to and including Photoshop CS3) and will need to be purchased separately. The most popular application for this – and the most effective – is Genuine Fractals from OnOne Software. Genuine Fractals allows an image to be rescaled to over 1000 per cent with no loss in detail.

Prague trees (below and facing page)

Most digital images should not be enlarged but, if necessary, interpolation methods can be used to restore some of the lost information.

Photographer: Steve Macleod.

Technical summary: Kodak Portra 160nc (natural colour) film.

Original image

The original image is sharp and clear so it should be possible to resize it using bicubic interpolation.

Image Size pop-up panel
The pop-up panel allows an image to be resized in proportion. If the resolution does not allow the image to be enlarged to the required size, it is possible to use interpolation methods.

Close-up of the original image
Here, the individual pixels of the original image can be clearly seen.

Close-up of the image after bicubic interpolation
Here, new pixels are inserted to create a larger image. The information for each new pixel is created by automatically reading the values of all the neighbouring pixels and calculating an average for each new one created.

Adjusting canvas size

Often mistaken for the Image Size menu option, the Canvas Size feature is used to extend the canvas, (which can be likened to photographic paper) to allow an image to be extended to, for example, add a border. This is also very useful if outputting images that are meant for display or portfolio use. This command is situated immediately adjacent to the Image Size command and is selected using Image menu > Canvas Size. It is also useful if additional elements need to be added or the image resized. If the box marked 'Relative' is checked it is straightforward to enter the dimensions to be added to the current image.

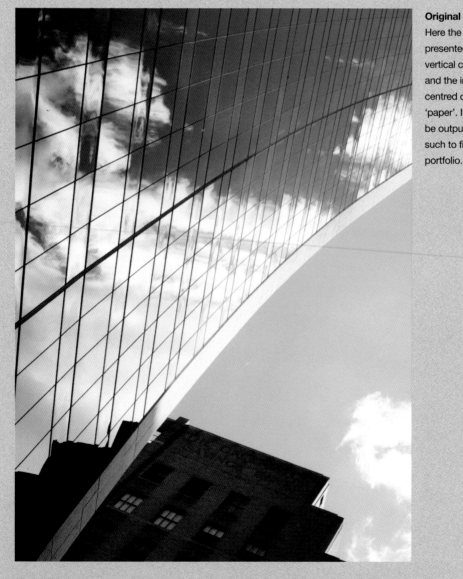

Original image
Here the image is presented on a vertical canvas and the image is centred on the 'paper'. It would be outputted as such to fit in a portfolio.

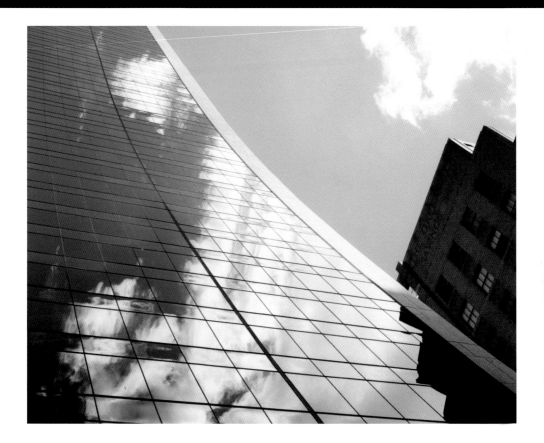

Rotated image

Here the image was rotated to landscape and then mounted on a new canvas size in proportion to the image. This alters the perspective of the viewer and adds to the dynamic shapes and forms of the image.

New York sun (above and facing page)

The abstract shapes and contrasting textures of this shot make it a dynamic and striking image. By rotating and cropping it, however, these features can be further enhanced.

Photographer: Steve Macleod.

Technical summary: Fuji 6" x 7" Rangefinder, standard lens, Kodak 160vc (vivid colour) film, processed normal, negative scanned and input into Photoshop, auto-colour balanced and cleaned.

Cropping images
As with conventional printing, sometimes there is a requirement to crop the image to make it more dynamic and to improve composition. Often, when looking at an image on screen, it is possible to see that the composition is not perfect when viewing the whole frame. It could, instead, be substantially enhanced if modified framing was to be used.

In the conventional darkroom the photographer might assess the need to crop an image when producing a basic print and the level of magnification can thus be adjusted to print only the selected area. Something very similar can also be done digitally.

To crop an image select the Crop tool from the toolbox. Drag the tool across the image from one corner of the intended selection to the other. The area of the image outside the crop will appear dimmed, allowing you to concentrated on the cropped area. Any fine adjustments can be made to the cropped area by selecting one of the handles (the little squares on each of the lines defining the crop) and moving them inwards or outwards until the perfect crop is achieved. Double clicking on the centre of the highlighted image will complete the cropping process.

It is also possible to crop in perspective. This is a useful feature that allows the user to adjust the crop lines to correct any verticals (or horizontals) in the image that are not straight. By dragging the corners of the selection to align them with any vertical or horizontal lines, the resulting image will be adjusted to realign these.

'The artist's world is limitless, it can be found anywhere, far from where he lives or a few feet away. It is always on his doorstep.'
Paul Strand

Cropped image

Cropping an image is a useful way of altering perspective and the shape of a digital image, much in the same way that the positioning of the darkroom easel can alter the effect of a print.

Basic digital colour and exposure correction

Once the size and scale of the digital image is finalised, attention needs to be focused on the colour, contrast and exposure of the image. Because digital images directly interpret the output from the digital camera, most photographers find that, errors and exceptions notwithstanding, most of their digital images will be pretty well exposed with good colour rendition. Where this is not the case, or it is felt that the camera's interpretation is not correct, it is easy to make further changes or modifications.

The Brightness/Contrast command

The obvious tool for adjusting the brightness and contrast in an image would seem to be the Brightness/Contrast tool. There is no doubt that in some cases this tool can make a good job of making these adjustments. However, it should only be used for making simple alterations as, unlike Levels and Curves, which apply proportionate adjustments to individual pixels, this command makes a universal adjustment to all pixels in an image. Despite this, the Brightness/Contrast tool can still be useful for quick checks and adjustments, and for working on those images that will respond to the types of correction it can apply. For images that need more thorough attention, the Levels and Curves commands will be far more suitable.

The Hue/Saturation command

The Hue/Saturation command allows the user to adjust the hue, saturation or lightness of a colour component, or all colour components, in an image. It comprises three controls, which can be applied to the whole image (master) or selections such as colour channels:

Hue: to alter the hue of an image, or parts of it, move the slider to the left or the right or enter numerical values into the value box. The slider and numerical values correspond to a number of degrees on the colour wheel. The distance between the new colour and the original colour on the wheel represents this value.

Saturation: move this slider or enter values to alter the colour saturation in an image. These values, again, correspond to the relationship between the original and new colour on the radius of the colour wheel.

Lightness: use this slider to vary the lightness of the image. Sliding to the right will add more white and to the left will add more black.

The bars at the bottom of the panel can be used to modify the range of colours used in the image for much more subtle effects. The top bar represents the original colour and the bottom bar, how the adjustments will affect all the hues at full saturation.

The Colorize option can be used to tone a greyscale image or to add a tint to create a monotone effect. Essentially, this option allows the user to apply an overall hue to the whole image.

Hue/Saturation/Lightness

The hue and saturation levels have been slightly increased across the image as a whole. The lightness has not been altered.

Colorize

Here, the Colorize box has been checked so that the whole image will take on a single hue. This hue is displayed in the bottom bar and can be adjusted using the sliders or by inputting the values manually. The adjustments here have meant that the image has taken on a green–brown hue.

Channel adjustments

The colour bars can be adjusted using the sliders to alter the colour temperature of each channel or the whole image. Here, adjustments are only being made to the red channel.

The Adobe Colour Picker

The Colour Picker in Photoshop allows a colour to be chosen from a colour spectrum or by specifying numerical colour values. It can be used for setting foreground or background colours or for setting targets in other tonal adjustment commands. Colours are often selected on the basis of hue, saturation and brightness but can also be selected using RGB, CMYK or other colour models. Whichever method is used, the panel also displays the values for all models, so it is useful for seeing how the colour is translated in other modes. It also allows the user to check whether the colours they are using are gamut- and web-safe.

Target highlight colour
The end point for highlight density and colour can be controlled via the Colour Picker menu, a particularly useful tool when preparing images for CMYK conversion.

Color Picker

Select target shadow color:

OK

Cancel

Custom

H: 318 ° L: 1

S: 59 % a: 1

B: 2 % b: 0

R: 5 C: 74 %

G: 2 M: 69 %

B: 4 Y: 65 %

050204 K: 88 %

Only Web Colors

Target shadow colour

As with the highlight regions, the end point for shadows can also be set and determined via the Colour Picker menu.

Variations

Just as the colour ring around diagram (see p. 74) allows the photographer to experiment with filtration in conventional colour printing, so too does the Variations tool for photographers working with digital images. This is a great starting point for comparing variations in colour and applying a relative correction and is particularly useful for looking at possible options for adjusting the colour qualities of an image. It is a very quick method of altering the colour in a controlled fashion in each of the shadow, mid-tone and highlight regions, as well as the overall saturation of the image. The increments of adjustment can be refined to suit the image and the level of correction required. You'll find this feature by selecting Image menu > Adjustments > Variation.

Variations

This application is an excellent way to visualise the colour temperature options available for an image.

The Levels command

As knowledge and experience in digital image manipulation grows, commands such as Brightness/Contrast will be used less and less. Instead, the Levels and Curves commands will be of more use.

Every tone in an image, from deepest black through to the brightest white is represented by 255 discrete levels. The distribution of these tones throughout the image are represented visually on a histogram. This histogram can give a lot of information about the image. In particular, it can show whether there is full tonal distribution (that is, are there any tones missing in the original?) throughout the image or specific areas of an image, such as individual colour channels, and whether the image is predominantly low or high key (that is, are either dark or light tones dominant?). It will then be possible – should there be a need – to modify the intensity levels of shadows, mid-tones and highlights in an image.

Unlike Curves, the Levels command only allows for the tonal distribution to be altered at three points: shadows, highlights and the gamma – the brightness levels of the mid-tones. These are represented by the three arrows on the slider bar in the adjustment panel. As such, the Levels command is useful for setting or preserving shadow and highlight levels and for making small adjustments to colour elements in an image.

With the Levels command, the highlight and shadow points can be specifically assigned to a particular image. This is especially useful if the image is in CMYK mode and is due to be reproduced in print. To do this:

1. Open up the Levels box.
2. Look closely at the highlight and shadow areas.
3. Double click on the Highlight dropper and the Color Picker box opens (A good average Brightness setting is 98 per cent).
4. Look at the image to identify the extreme highlight, click on this and click OK.
5. Repeat the process for the shadow endpoint, but this time set the brightness figure to somewhere in the region of 3 per cent.

The Levels command can also be used to correct colour casts. Once the menu is active choose a channel and ensure that the preview box is checked. For example, select the red channel level; sliding the gamma arrow to the left will increase the warmth of the image. A useful effect of this process is also the neutralisation of an image. By clicking on the mid-tone or grey picker, select an area of the image that looks neutral grey, and the Levels will automatically adjust all of the channels' gamma settings to remove any colour cast.

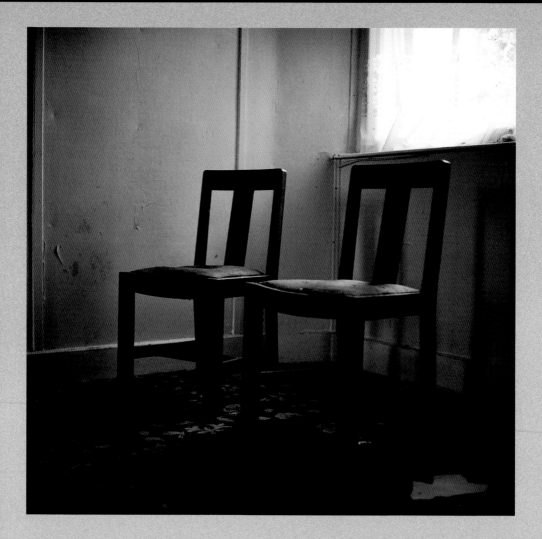

Original image

The areas of shadow and light in this image add to its odd composition, provoking an uneasy and strange reaction from the viewer.

Chairs, Achvarasdale (above and following pages)

These chairs were found in an abandoned house with belts and straps tied to them so an unsettling mood was well suited to the image. The levels histograms opposite show the make-up of colour and light and shadows in the image.

Photographer: Steve Macleod.

Technical summary: Rolleiflex 2.8 GX, Kodak 400VC film, drum scanned and worked on in Photoshop.

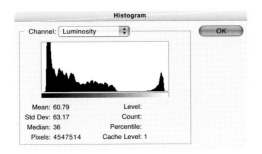

Luminosity histogram

This graph shows the relationships between the different tonal levels. The left-hand end of the bar represents shadows, the right-hand the highlights and mid-tones are represented at the centre of the bar.

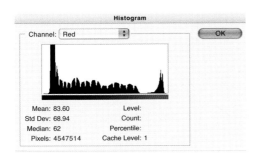

Red channel histogram

Here, the histogram shows fairly even tone throughout the tonal levels in the red channel. There is slightly more detail in the shadow areas.

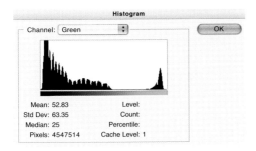

Green channel histogram

Here, the histogram shows predominant shadow detail. The detail on the right is likely to represent the tones shown in the window area.

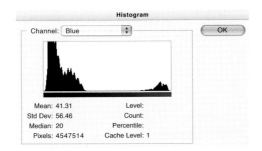

Blue channel histogram

The histogram for the blue channel shows the deepest shadow areas as most defined.

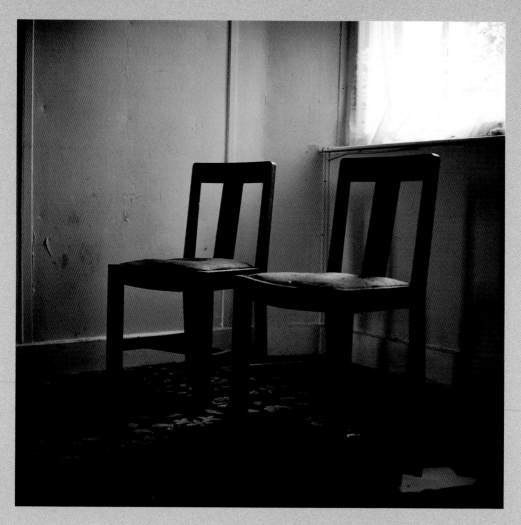

Levels of original image

The levels for the original image are set at the default values.

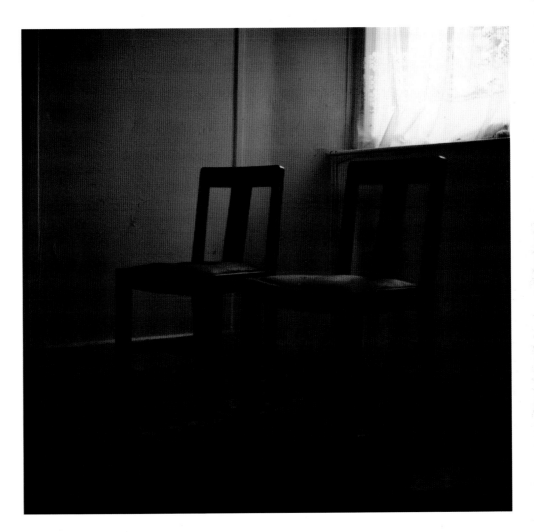

Levels-adjusted image

Having already been colour corrected, the image was then adjusted using the Levels application. Both the input and output values have been altered to darken the image and create a moodier feel, which was how the actual scene originally felt.

Prague trees (below and facing page)

This was shot on a cold winter's morning. The shadows cast by the sun on the wall were sharp and crisp but the first print did not accurately show the colour temperature of the original scene.

Photographer: Steve Macleod.

Technical summary: Not available.

Original image

This is the original scanned RGB image. The definite yellow colour cast needed correcting in order to accurately reflect the cold light and physical conditions in which the photograph was shot.

Neutralised image

The Levels menu was selected from the image drop-down menu and the middle/grey picker activated. An area of the image that appeared neutral grey was selected so that the Levels automatically neutralised the image based on this tone. Neutralising a colour cast in this way changes the intensity of the middle range of grey tones without dramatically altering the highlights and shadows.

Curves

At first glance the **Curves** command (Image menu > Adjustments > Curves) looks very similar to the **Levels** command. In fact, it is much more flexible and, ultimately, much more powerful. As with the Levels command, the contrast and density of the image can be easily adjusted and individual colour channels likewise, but instead of just the three shadow, gamma and highlight point, the Curves command allows the user to adjust up to 14 points throughout the image's tonal range.

The Curves dialogue box's key feature is a graph, bisected by a diagonal line. This represents the correspondence of the input (original) and output (new) values of an image; each of the axes represents a tonal range from 0 to 255, the vertical axis represents input values and the horizontal, output. As with Levels, the bottom left of the linear line represents 0 (or the shadow regions) and the top right represents 255 (or the highlight region). Thus, bowing a curve upwards will lighten an image and bowing the curve downwards will darken it. Steeper sections on the graph will have more contrast and flatter sections will have lower contrast.

Like the Levels command, the Curves command can also be applied to specific colour channels, as well as to the whole image.

Layers and adjustments layers

One of the most powerful features in Photoshop – and just about every other image manipulation application – is one that tends to be taken for granted: **Layers**. Rather than apply all the manipulations available directly to an image it is possible to apply them to particular layers. It is convenient to think of these layers as acetate sheets that can be laid over the original image. Manipulations can be applied and different image elements added to each of these sheets. Viewed from above, the image will then appear as a single composite image. Then, should an effect need to be removed later, it can be. It is also possible to change the order of multiple layers so that effects and changes can be stacked in a different order.

Photoshop actually goes a step further and provides a second kind of layer known as an Adjustment Layer. This allows effects such as changes to the brightness and contrast, colour balance, Levels, Curves (and more) to be applied to an underlying layer, again without compromising that original layer.

curves a feature of most image manipulation applications that allows the input and output values of colour, brightness and contrast to be varied

levels a feature of most image manipulation applications that allows the user to adjust highlight, mid-tone and shadow details of an image

layers a Photoshop feature that enables different elements of a file to be stored in an application. Layers can be separated and worked on before culminating in the final image output

Oxford Street, London (this page and following page)

Morning sunlight in summer leads to bright illumination and deep shadows – often beyond the conventional latitude of an image. The Curves command will allow us to bring out some detail that might otherwise be lost.

Photographer: Peter Cope.

Technical summary: Nikon D200, 24mm lens F/8, 1/400s at ISO 100.

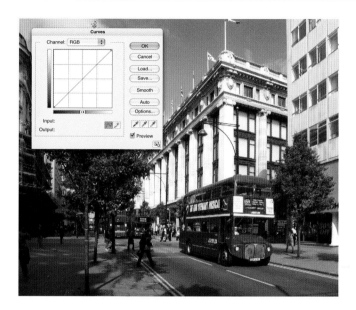

Original image

When the Curves tool is first selected on an image the dialogue box appears showing the default graph with its straight line, illustrating a direct correspondence between input and output levels.

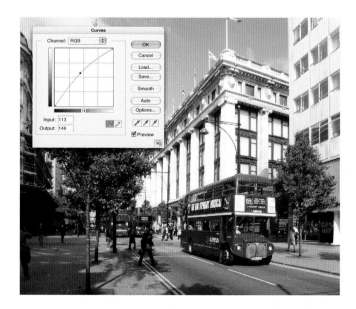

Lifting the mid-tones

Clicking on a mid-point along the Curves line will create an anchor point. Drag this anchor upwards to lighten the mid-tones in the image. Other tones will be modified more modestly, according to how close they are to the anchor point. By doing this, areas such as the tyres on the bus become more visible.

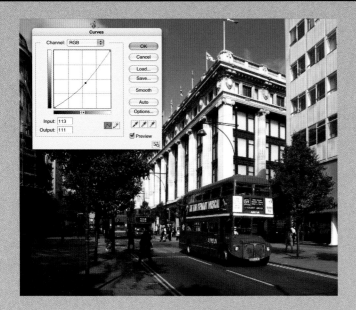

Darkening mid-tones

Drag the anchor point downwards at the mid-point and the mid-tones will darken. Here, elements such as the bus tyres and the sky look slightly darker.

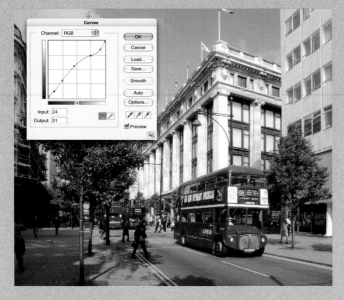

Using Curves for exposure control

By adding multiple anchor points and adjusting accordingly the effective exposure in the image can be controlled. This is useful when a component of the tonal range throughout the image needs to be modified. Applying a modest lift to the mid-tones here has improved the overall exposure while a modest lift to the shadow area (using the leftmost anchor point) has allowed more detail to be revealed in the darkest parts of the image.

Digital dodge and burn techniques

Just as dodge and burn techniques are useful – many will say essential – in delivering the best from a conventional photographic print, so can the effects be achieved in digital work. Accordingly then, the digital darkroom has a similar set of tools. The effects that they produce, however, are much more controlled and much easier to achieve. This is certainly a case of the digital world building on the foundations of the conventional and delivering results that are much better. In particular, results can be seen straight away and, if they don't look right, they can be removed at a stroke.

Dodge and burn tools can be found in the toolbar. When either the dodge or burn tool is selected, the user will also need to:

1. Select a brush type to apply the effect with – a large soft brush for large areas, a smaller soft brush for more precise shading (or lightening).
2. Select the tonal range to which changes will be made: shadows, highlights or mid-tones.
3. Select an exposure. As with conventional manipulations, it is important to be gentle with the changes applied, so use an exposure of five per cent as a start point.

It is worth noting that in digital photography the dodge and burn tools are essentially designed for use when making small-scale corrections after more major corrections have been applied using Levels or Curves. Dodging and burning makes a potent image an outstanding one.

If using Photoshop CS 1 (or later), there is an additional command that can be used to precede the dodge and burn tools, which can save a considerable amount of time. This is called Shadow/Highlights and can be found by selecting Image menu > Adjustments > Shadow/Highlights. It is designed to affect the whole image (and, as such, does tend to be a little heavy-handed if not used with discretion) and will reduce the brightness of any image highlights or brighten the shadow areas. The amount of dimming or brightening is proportional to how bright or dark pixels are in the image.

'Anybody who says that photography is 95 per cent feeling and five per cent technique is a coward.'

Dean Collins

It is sad but true that few photographers today will explore the full creative potential of colour photographic printing. Many photographers – whether they shoot on film or digitally – are only too happy to embrace digital printing techniques, techniques that allow so much more control. But this might be forgiven seeing as colour printing is so limited: unlike black-and-white printing, there are major restrictions to the amount of manipulation that can be done to a colour image in the darkroom. This is mainly due to the fact that the photographer is constrained by the chemistry (which allows less latitude for experimentation than black-and-white chemistries) and has to consign the processing to a machine.

Of course, it is important to acknowledge that there is a major benefit to this: consistency. Multiple copies of the same print can be made with the assurance that, if equal temperature and exposure have been consistently applied, the results will be exactly the same for successive prints.

Neither would it be true to say that there is no room for creative input at all; it is possible to manipulate images at the preliminary stage of colour print production and it is good to be able to recognise the way that colour (particularly) can affect and change the mood representation of an image.

This chapter will examine more closely some of the issues affecting – and determining – the way colour prints are made. A greater understanding of colour theory will help to deliver punchy or evocative prints and it is possible to master a few darkroom tricks that can really enhance images.

'You press the button, we do the rest.'
George Eastman

The tree, Brecons (facing page)
Shot on a winter's day this photograph accurately conveys the scale and texture of this massive tree.

Photographer: Steve Macleod.

Technical summary: Canon Powershot, 15mb TIF file, colour balanced in Photoshop.

Colour and colour harmony

Colour is a potent component of any image. Strong colours will have a more direct and obvious impact than muted colours. But each has its place; think of those travel shots that show sunny beach scenes: deep, almost oversaturated blue skies, and azure seas combined with the bright reds and yellows of beach umbrellas, producing shots that are guaranteed to sell well to the holiday brochure market. Conversely, moody, misty shots taken around dawn are successful on account of the gentle pastel colours that make up the shot.

The type of lighting used in a shot will also have some bearing on the impact of a photograph: primary colours are dependent on the quality of light to enhance their strength, direct sunlight can deplete the vividness of a colour by lightening it, whereas a colour will look most vivid in bright diffuse light.

The original choice of film will also affect the colours that can be translated to print, so it is worth experimenting to find the right balance between film and print values. If you want to shoot soft, muted colours as a matter of course, steer clear of Fuji's Velvia; but if you want shots with that – in saturated colour terms – wow factor, make it your key emulsion.

Colours tend to lose their intensity if they are darkened or lightened; the colour becomes desaturated with the addition of black or white, and this can be translated into colour losing its intensity in shadow and highlight in printing.

When we look at the colour in an image we will all see something slightly different. That comes down to interpretation and our own individual visual acuity. There are, though, some common factors that contribute to the overall feel of an image. Combinations of colour and their intensity will determine whether a photograph looks pleasing and harmonious to the eye or whether it becomes challenging to look at. These factors are all displayed on the colour wheel and can be separated into three main characteristics.

Dominant colour

Exploiting the richness and texture of a single bright colour can often concentrate the impact of an image. The more intense the colour, the more impact it will have, but go too far and the results can look garish. A good example is the shot opposite of a rig blowout. The eye is immediately drawn to the main subject of the image. In black and white, even if the blowout itself was emphasised, the impact would simply not be there.

Rig blowout, Brent Bravo (facing page)

Shot as part of Brent Bravo offshore redevelopment assignment for Shell UK.
The transparency accurately captures the saturated colour of the subject.

Photographer: Steve Macleod.

Technical summary: Nikon FM2, Fuji RDPII 35mm film rated normal and push processed 1/2 stop.

Limited colour

Colour images can appear monochromatic in colour when subtle colour shifts are employed and colour saturation is stripped from the image. Natural masks, such as rain and fog, will often create an element of soft light, as will early morning and evening sun. Another method to achieve this – or assist this – is to break the conventional rules of image composition and shoot directly into the sun without a lens hood.

Images shot in this way aim to retain the merest hint of colour; it is this that distinguishes them from images that might otherwise have been shot in monochrome.

Snow and sunset (above)

The monochrome-like range of greys and blues in this image accurately reflect the cold, bleak landscape that was originally shot.

Photographer: Steve Macleod.

Technical summary: Nikon FM2, Fujichrome Provia RDPII film rated normal, processed at +1/2.

Saturated colour

In direct sunlight, colours can appear saturated in hue. Colours will look best in direct diffuse light, where contrast is minimised and the softer light will create a colour harmony. There is a very fine line between an image that uses a saturated colour for impact and one that uses saturated colours destructively. Too much saturated colour – particularly where the colours come from different segments of the colour wheel (opposites, in particular) can produce an image that is difficult to view. The colours, to use a hopelessly non-technical term, clash. Non-technical it may be, but it will be the one that anyone viewing the image will use. And they will be using it in a disparaging way.

Red shadows, Brent Charlie (above)

Taken in direct sunlight, the colours in this image appear deeply saturated, creating an image with warmth and impact.

Photographer: Steve Macleod.

Technical summary: Nikon FM2, Fujichrome Provia RDPII 35mm film rated normal and push processed 1/2 stop.

Print flashing

A popular technique in black-and-white print production is print flashing: exposing the photographic paper to light prior to, or soon after, the exposure to a negative in the enlarger. The same process can be used in the production of colour prints but will immediately raise two questions:

1. Why would we want to do this?
2. Why doesn't the exposure to light fog the film, rendering it unusable?

To address the second question first, all photographic papers have an exposure threshold level, below which the paper is not sensitive to light (or at least, not sensitive in the traditional sense). Only if the paper is exposed to more light than this level – called the inertia point – does the film begin to fog. This leads us on to the first question: exposing the paper to a lesser amount than that determined by the inertia point gives the paper a kick start when it comes to the final exposure. When exposing the paper to the negative, the paper is in a sense primed with an invisible latent image, upon which the final image is built. Therefore, none of the actual exposure is lost in having to build the paper's sensitivity to the inertia point.

The nature of this effect means that it makes little difference whether you apply the flash of light prior to or after exposing the paper to the negative. The results will be identical in either case. Because this involves a second exposure stage when printing (and possibly requires that the enlarger is reconfigured), some photo printers prefer to take a short cut and pre-flash whole boxes of paper at a time at a time. This is not normally recommended as, if the film is not used in a short timescale, there is a risk of the pre-flash becoming a fog on the film, rendering the whole batch of pre-flashed paper unusable.

Using print flashing

How is pre- or post-flashing used? The following method tends to be both simple and effective:

1. Expose the paper to the negative.
2. Apply any exposure-based effects, if necessary, such as burning and dodging.
3. Remove the negative from the carrier but leave the paper in the enlarger easel.
4. Replace the now-empty negative carrier into the enlarger.
5. Expose the paper sheet for the pre-determined minimal exposure.
6. Turn off the light source and process the paper as normal.

How long should the exposure in step 6 be? In order to find the optimum exposure, it is necessary to undertake a simple test on each type of paper to be used. This is known as a base fog test.

Producing a base fog test

The basis of the base fog test is to produce a test print (as in the previous chapter) by exposing the paper – with no negative in the enlarger – for progressively longer times. This will be done until an exposure is reached whereby the amount of light begins to fog the paper. At this point the light has achieved its full aim of overcoming the paper's inertia point and is now simply fogging the paper.

Because each type of paper has a different inertia point, there are very few guidelines to follow when carrying out a base fog test. In addition to this, the amount of light that falls on the baseboard of an enlarger can also vary widely, according to the actual (rather than the rated) output of the light source, the distance of the baseboard from the head and the type of lens being used. Even more annoyingly, sometimes even the age of the light source can have a bearing because many light sources can change their light output and even colour with time.

Begin by stopping the lens down to your normal working f-stop (say f11). Use an opaque sheet of card to cover the paper and make exposures in increments of half a second across the paper. When you process the paper (using your normal RA-4 chemistry) you will see a print that, for the most part, is white but then a stepped greyscale appears. You will need to make a note of the exposure time that corresponds to the first grey strip: the first fogging of the paper. The exposure necessary to reach the inertia point will be 0.5s (or whatever increment you have used) less than this.

Base fog test sheet
Exposure in half-second increments shows a typical base fog test sheet.

Essex House, New York (below and facing page)

The bright light in which this photograph was shot created high contrast between the highlights and shadows so it was post-flashed to add more warmth and depth.

Photographer: Steve Macleod.

Technical summary: C-type analogue print, printed on Kodak Endura matt paper.

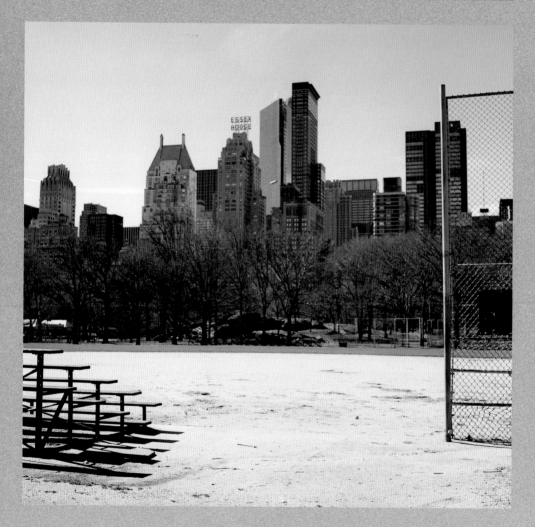

Original image

The standard print image contains vivid colours.

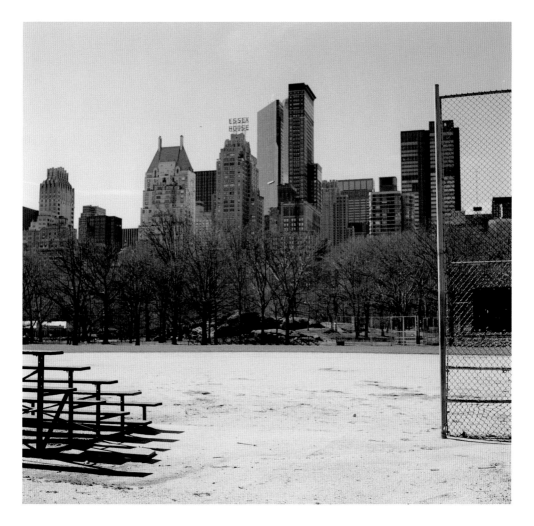

Post-flashed image
Here the image has been flashed with a warm tint to reduce the contrast slightly.

Signpost, Melvich (below and facing page)

The deeply saturated colours in the original image were too strong and left the image with little definition.

Photographer: Steve Macleod.

Technical summary: Mamiya 7mkII, Kodak 400vc (vivid colour) film, cropped C-type analogue print, printed on Fujicolor Crystal Archive gloss paper.

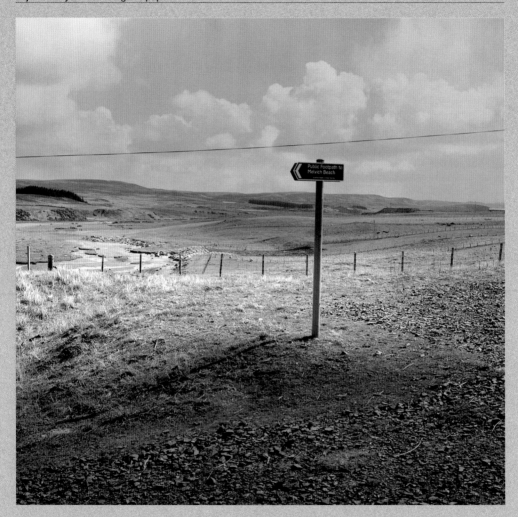

Original image

The standard print image contains vibrant colours that are too strong.

Post-flashed print

The second has been flashed with a colder, more blue, flash tint. The print is heavier and contrast has dropped and there is more definition in the clouds and sky.

Results of print flashing

Provided print flashing is conducted as described here, there should be no side effects. However, it is important to be aware that the print contrast can be compromised slightly through flashing paper. This can, of course, be used to your advantage should you need to modify the contrast of your print.

There is also a risk of slight overexposure of the whole image. This can be compensated for by increasing the contrast grade of the print and cutting the initial exposure during the working of the print. Also bear in mind that if you intend to tone your print afterwards, you should increase the pre-flash to compensate for any contrast changes that will result from print bleaching.

Successful proponents of the pre-flash technique will also selectively flash discrete areas of a print to alter the effect of subtle shadow detail. This is done by recreating shapes and mass for the image that will shield the effect of any flashing in exactly the same manner as with dodging and burning. Note also that flashing will not compensate for poor film exposure and development. It should not be used as a method of rescuing an initially below-par image.

Author's tip

Photographically produced prints (as distinct from digital prints) are generally formulated to deliver the best results for the longest possible periods. The lifetime of prints at their optimum quality will vary according to display conditions but be assured that prints produced today have outstanding performance with regard to longevity. Paper manufacturers base their estimates for print longevity on a standard usage scale. Kodak, for example, describes longevity on the basis of, for home display, a light level of 120 lux (a typical domestic interior) for 12 hours a day. A temperature range of 20 to 23 degrees Celsius and a relative humidity of 50 per cent are also quoted.

The dyes used in the papers, like all chemicals, will fade or change with time and also from exposure to sunlight, ultra-violet radiation, heat and humidity. To retain optimal print quality for the longest time, follow these guidelines:

• Display prints using the lowest light level necessary to display them to their best.
• Use tungsten light sources wherever possible.
• Use UV-absorbing glass to frame prints or, if using lamps with a high UV output, UV filter glasses over the lamps.
• Use a card matte to prevent a print making contact with framing glass.
• Maintain the viewing environment at as low a temperature and humidity as possible.

Specialist printing

Creative printing in black and white presents a wide range of opportunities including tinting, split toning and even duochromes, through both conventional and digital techniques.
This could leave the colour-print photographer feeling a little cheated. However, there is still some scope for creative printing. Of course it has long been possible to print on to papers that offer for example, canvas or watercolour finishes, but there are also other papers that provide specialised results. A good example is Kodak's Endura paper range. This provides a selection of papers including:

- Endura Metallic
- Ultra Endura
- Supra Endura
- Endura Transparency
- Endura Clear Display

Endura Metallic is specially designed for producing striking, three-dimensional-appearing prints with an ultra-bright background. It boasts one of the most extreme paper emulsions in terms of sharpness, brightness and colour saturation.

Ultra Endura is designed to produce prints with high contrast and high colour saturation and is ideal for high-impact commercial images.

The Supra variant is less overt in terms of colour and delivers more authentic colouration, particularly for skin tones.

The transparency and display versions produce vibrant images designed to be backlit in light boxes or display units.

Paper ranges such as Endura are becoming increasingly popular because they also produce variants designed for digital printing. This makes it possible to use a single class of media to produce prints from both digital and conventional sources. For just about all Endura papers the longevity is quoted at between 100 and 200 years for domestic environments and up to five years in bright, commercial environments.

'The mystery isn't in the technique, it's in each of us.'
Harry Callahan

Sheep path, Port Skerra (facing page)

Medium format Rangefinder cameras are ideal for landscape, being portable but still providing a decent enough size negative to print from.

Photographer: Steve Macleod.

Technical summary: Mamiya 7mkII, Fujicolor Reala film, printed on Fujicolor Crystal Archive gloss paper.

Colour control

Raw images, or those to which modest or simple corrections have been made, will need to be assessed early on for accurate colour balance. For a standard image this will be a case of checking that the whites are truly white and the neutral colours truly **neutral**. When the sun is low in the sky or if shooting conditions involve mixed lighting sources it is easy for the scene to take on a **colour cast**. Sometimes this may be intentional, but it is often less welcome. Here we will see how such colour casts can be corrected.

Colour balance

In film photography it is easy to take for granted the way in which the colour temperature of light (that is, the colour cast produced by the principal lighting source) translates to the film being used. Colour correction **filters** can be used to adjust the nominal colour balance of each film to make it better matched to the precise lighting, for example to reduce the warmer light of the evening or warm the cooler light found in scenes lit by pure blue skies. However, if this compensation is applied incorrectly or insufficiently it is possible to correct at print stage.

Obviously, when working digitally there is no need to match film to the lighting. Instead, a feature that is found on just about all digital cameras can be used to ensure that the scene the sensor records is precisely matched to the light sources present, no matter how extreme they may be. This is the **white balance** control.

A typical white balance control allows the photographer to select from a number of presets: these might be considered similar to using different film types, although the basic range of options is generally wider. It is also possible to set the camera to auto white balance, which sets the camera to continuously monitor the incoming light sources – no matter how disparate they are – and sets the camera electronics to apply the best correction.

If it is too late for this and corrections need to be made post-shoot, one of the simplest methods is to use the Auto Adjustments applications found in the Image > Adjustments drop-down menu. These are often called the quick fix commands because they apply a quick fix using a rule base that is applied to any image. There are three options here:

Auto Levels: this automatically adjusts the black point and white point in an image and redistributes intermediate pixels proportionally. Auto Levels increases the amount of contrast in an image so it can give good results to images that need a simple contrast increase. It can adjust channels individually so may introduce or remove a colour cast.

neutral areas of a photograph that have a pale grey, cream or beige tone
colour cast an overall tone that affects the representation of individual colours in an image
filter in analogue photography, this is a coloured screen that covers the camera lens, or is used to control the contrast in darkroom enlargers. In digital photography, it refers to a manipulation application process
white balance custom balance on a digital camera will achieve accurate colour rendering. Point the camera at a sheet of white paper in any given location and the camera will compensate.

Auto Contrast: this adjusts the overall contrast and mixture of colours in an RGB image. It does not adjust colour channels individually so won't create or reduce a colour cast. It clips (makes white or black) the shadow and highlight values by 0.5 per cent (ignoring the first 0.5 per cent of either extreme) and then maps the remaining pixels proportionately. Thus, highlights appear lighter and shadows darker, making this a useful command for improving continuous images, but not flat images.

Auto Colour: the colour and contrast of an image can be adjusted using this command. It does this by searching and identifying shadows, mid-tones and highlights and neutralising mid-tones using a target colour. The default colour for this is RGB 128 grey but this can be altered in the Auto Colour Corrections Options. Like Auto Contrast, this command also clips the shadow and highlight values by 0.5 per cent.

The Auto Colour Correction Options panel can be used to specify target colour values and clipping percentages when using Auto Levels, Auto Contrast and Auto Colour, as well as the auto option on both the Levels and Curves commands. The three algorithms refer to contrast (Enhance Monochromatic Contrast), levels (Enhance Per Channel Contrast) and colour (Find Light & Dark Colours). Target colours and clipping percentages are then specified for shadows, mid-tones and highlights.

The Colour Balance command also allows the user to make generalised corrections to colour in an image. It changes the overall mixture of colours and allows the user to make changes to shadows, mid-tones or highlights. Three sliders are displayed with a colour at either end: cyan to red on one, magenta to green on the second, and yellow to blue on the third. By dragging the slider towards a colour, that colour will be made stronger in the image, and dragging the slider away from a colour will decrease the amount of that colour.

Auto Color Correction Options

Algorithms
○ Enhance Monochromatic Contrast
◉ Enhance Per Channel Contrast
○ Find Dark & Light Colors

☑ Snap Neutral Midtones

OK

Cancel

Target Colors & Clipping
Shadows: ■ Clip: 0.50 %
Midtones: ▢
Highlights: ▢ Clip: 0.10 %

☐ Save as defaults

Auto Colour Correction Options
The Auto Colour Correction Options allow the user to specify target colours and clipping percentages for shadow, mid-tone and highlight areas in each channel.

Thai temple (below and facing page)

There are a number of ways in which a colour cast on an image can be rectified. Here, the effects of Photoshop's Auto controls can be seen.

Photographer: Steve Macleod.

Technical summary: Kodak 160vc (vivid colour) film, drum scanned as TIF file.

Original image

This file is presented as scanned and has a warm cast to it.

Auto Contrast

In this example using Auto Contrast, the contrast has increased but the colour cast is still apparent.

Auto Levels

Using the Auto Levels command, the image has been neutralised. Notice that the contrast has also increased.

Auto Colour

The final example has been adjusted using Auto Colour. The shadow value was left but the clipping value of the highlights was set to 0.10 per cent and the Snap to Mid-tones box was checked to neutralise those values.

Colour blending

If colour balancing controls are not enough, many image editing applications allow for colour blending to be carried out. Such adjustments can cause unrealistic and vivid colour changes, so it is important to use these processes carefully.

Channel Mixer

Channel mixing can be used to tint colour images or to tone monochrome or greyscale images. A standard colour image (like that which may be seen on-screen) comprises three images, one red, one green and one blue. These component images are commonly called **channels**. The Channel Mixer will enable the user to select each of these and vary the amount of each that contributes to the final image. Generally the values in each of the channels will default to +100 per cent in the Source Channel drop-down panel. The values can be varied on the condition that the percentage contribution of all three channels adds up to +100 per cent for the image to appear neutral. Minus values can also be used and very subtle colour shifts can be applied using this method, to change the overall feel of an image. Two useful controls let us adjust the colours in an image selectively rather than adjusting the **tone**, colour or **saturation** as a whole. These are the Colour Range control and Selective Colour.

Colour Range

This can be found by choosing Select Menu > Colour Range. This option allows for selections to be made according to the colour taken from either sampled pixels or preset pixel values. This tool is handy when adjusting the dominant colours within an image. It is also useful for correcting colours that might fall out of the **gamut** range, for example when changing from RGB to CMYK colour modes, or those outside the gamut of the paper used for printing. The precision of this tool can be varied by clicking on the + and – picker and the Fuzziness slider gives further control over how many tones close to that of your selection are also included. The command can be used repeatedly so that changes are built up slowly and subtly.

Selective Colour

High-end scanners and separation programmes tend to use this. It is primarily used as an application for adjusting the process colours (that is, the red, green, blue, cyan, magenta, yellow and black colour components of an image in RGB or CMYK mode. It is sometimes considered to be very similar to the Hue/Saturation control except that individual colours can be selected for adjustment. Other colours are left untouched, making it very useful for images that are predominantly made up of a single, dominant colour.

channels individual red, green and blue components of an RGB image

tone the overall effect of colour, light and shade in an image

saturation the intensity of colour in an image, usually measured in comparison to white

gamut a representation of the extent of a colour palette used for printing, displaying or recording a digital image

Pool (below and following pages)

After being drum scanned, this image appeared flat and dull. This was adjusted using channel mixing techniques.

Photographer: Steve Macleod.

Technical summary: Kodak 160vc (vivid colour) film, drum scanned in RGB at 300dpi, 100mb file.

Original image

The original negative for this image was scanned in RGB and input into Photoshop. The image looked a bit dull and flat.

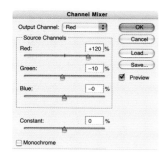 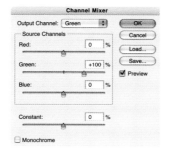 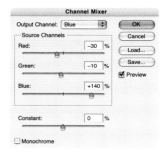

Channel Mixer (above)

Initially, the dull grey bias of the file was corrected using the Auto Colour command. The RGB channels were then adjusted individually.

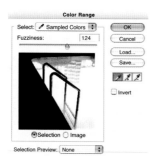

Color Range (left)

In order to increase the hue and saturation of the water in the pool only and to leave the poolside as it was, the Color Range panel was brought up and, using the colour picker (see pp.96–97), two areas of blue from the pool were selected.

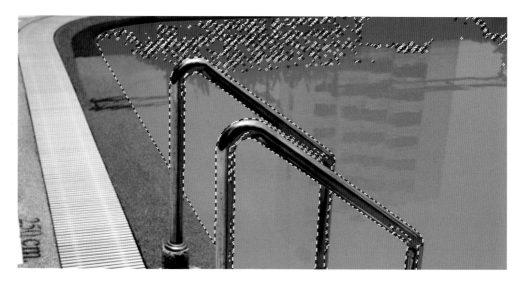

Color Selection detail (above)

The areas of the image containing these colours were then highlighted and the blue channel was opened.

Pool (above)

This allowed the colour shift seen here to be made. The Healing Brush (see pp.142–143) was also used to remove the distracting numbers to the left at the edge of the pool.

Gradient fills

The most straightforward method used by photographers to create colour blends in an image is to use the Gradient Fill mode. This introduces colour in a new layer, which must be blended with colours in the other layers. A gradient fill introduces a colour (or blend of colours) to the image foreground and background in a gradation of brightness, from light to deep. These gradients can take a number of forms:

Linear gradients shade from the starting point to the end point in a straight line.
Radial gradients shade from the starting point to the end point in a circular pattern.
Angle gradients shade in an anticlockwise sweep around the starting point.
Reflected gradients shade on a symmetric linear on either side of the starting point.
Diamond gradients shade from the starting point outwards in a diamond pattern.

Blending modes

When using gradient fills, it is vital to use the appropriate blending mode, which determines how a layer interacts with that below. Typically, a gradient fill would be added to a new layer and then blended with that gradient layer using one of several options. When considering these, remember that 'Base colour' refers to the original colour in the image, 'Blend colour' refers to the colour being applied with the editing tool and 'Result colour' refers to the colour that results from the blend. Some of the most commonly used blend modes are:

Hue: this blend mode creates a result colour that has the luminance and saturation of the base colour and the hue of the blend colour.
Saturation: when this blend mode is used the result colour has the luminance and hue of the base colour and the saturation of the blend colour.
Colour: the result colour has the luminance of the base colour and the hue and saturation of the blend colour. This mode preserves grey and is good for colouring monochrome images or tinting colour images.
Luminosity: the blend colour brightness replaces the base colour and the hue and saturation are untouched.

Gradient Maps

These map the equivalent greyscale range of an image to the colours of a specified Gradient Fill. Thus, the shadows in an image would be one end-point and the highlights another – the mid-points would be mapped to the gradations in between.

Twin towers (below and following pages)

Having been scanned in as an RGB image, the sky appeared bland and without depth. A Gradient Fill was used to rectify this.

Photographer: Steve Macleod.

Technical summary: Kodak 160nc (natural colour) film, drum scanned at 300dpi, 150mb file.

Original image

The darkest part of the sky was selected as a sample colour for gradient blending.

Gradient layer

A gradient layer was then added to darken the sky using the sampled colour. To darken the top of the image another gradient layer was added and a multiple selection was made, darkened and given a lesser opacity of 80 per cent. As the blue channel had the most contrast, this too was edited.

Gradient map 1

Gradient maps can have a variety of effects on an image. Here, a 45 per cent cold gradient was applied to both the foreground and background to create a sublime, dream-like feel to the image.

Gradient map 2

Here, a coloured gradient map has been applied to both foreground and background, creating a deeply saturated and very unnatural effect.

Gradient map 3

A neutral tone gradient map applied to just the foreground creates a much more subtle and natural effect.

Retouching digital images

No matter how clean the darkroom or how proficient the photographer, a traditional print will always have the odd blemish that needs some remedial action. That blemish might be a fleck of dust, a scratch on the negative or a spot or mark on the face of a subject that needed concealing. To conceal such blemishes on a conventional print requires a degree of artistry on the part of the photographer, who would need to use some opaque paints and dyes to retouch the image.

Many photographers would shy away from this and delegate the task to their pro-lab. Fortunately, the digital darkroom enables the photographer to make corrections such as this, and a lot more besides, to digital images with ease.

The Clone/Rubber Stamp

Digital photographers tend to use the Clone tool for one of two reasons: to remove unwanted parts of the image or to add new elements.

The Clone (or Rubber Stamp) tool clones – or copies – pixels from one part of a scene to another. In doing so it can be used to cover up unsightly objects or used to copy in a new element (often in order to produce group portraits from subjects that may not have been part of an original scene). In this way, subjects from two or more images can be combined to produce a montage.

To use the Clone tool, begin by defining a point where you want to clone pixels from. If, for example, you wanted to remove a road sign in your photo you might begin by defining a patch of adjacent sky. Next move the cursor to the point at which you want to 'paint' on these new pixels (note that the object is not being removed in this process, but rather painted over to conceal it). When you press your mouse button the pixels will be cloned to the new location. As the mouse is moved (or pen, if a graphics tablet is being used) to paint over the object, the point you are sampling from moves in parallel.

When cloning like this it is essential that you aim for realism. You need to ensure that:
- There are no obvious or hard lines between cloned and original pixels: use a soft edged brush to effect the clone.
- Cloned pixels are not taken from an area too close to the original. This will produce repeated pixel panels known as 'zebra striping'.
- There are no colour differences. This can be surprisingly difficult when cloning sky or areas of continuous colour; variations can be slight but will be made obvious by the cloning process.

Stop, Look, Listen (facing page)

Part of a larger landscape, this signage is obviously intrusive. The complexity of the background initially suggests it would be hard to remove.

Photographer: Peter Cope.

Technical summary: Fujifilm FinePix S2 Pro 35mm lens, f/8 1/250s at ISO 160.

Original image

Even the best potential shots can be ruined by a misplaced object, in this case a piece of street signage.

Cloning pixels

An area of sky adjacent to the sign was selected and the sign was painted over with these pixels. Here the clone-from point is indicated by the cross and the clone-to point by the circle.

Painting over

It is important to change the clone-from point so that the pixels are always closest to the object being painted over. This way any discrepancies due to colour variations will be avoided.

Final image

It is also important to ensure that the clone-from point varies so that there is no exact (and obvious) copy of an area in the background.

Young girl (below)

It is also possible to remove small inaccuracies from a digital image using the Healing Brush and Patch Tool. Here, the mark appears on the girl's face, which is a difficult and complex area to work on. The Clone/Rubber Stamp Tool would not be suitable for this kind of correction.

Photographer: Peter Cope.

Technical summary: Fujifilm FinePix S2 Pro.

Original image

Whether due to digital artefacts, damage to the original negative or even drying marks on a transparency, inaccuracies such as these compromise an image.

Making the correction

An area of skin of approximately the same size and shape and taken from a nearby area is selected. With this tool, colour and tone are matched automatically. The patch is then dragged and dropped over the area to be corrected.

Final image

The patched image shows absolutely no evidence of the original deficiency, nor the correction. From this, it is easy to see that, where useable, this is a much swifter and more effective correction tool than the Clone/Rubber Stamp.

The Healing Brush and Patch Tool

The Healing Brush is very similar to the Clone Tool and is generally considered as an evolution of the latter. The two work in much the same way, but the Healing Brush will blend the cloned pixels with those of the destination to produce a more subtle clone. It essentially matches the shading, lighting and texture of the original pixels. It is mostly used for touching up portraits.

To use the Healing Brush select it from the toolbar and then Alt/click to pick the selection point to sample from. Release the mouse button and click to repair the specified area. The tool can be used on both the background layer or on a copied layer, and the brush size and mode can be changed to suit the image texture from the palette.

The Patch Tool is a variation of the Healing Brush. Rather than painting with pixels, the Patch Tool uses a technique whereby a region of the image is selected and pasted over the area to be concealed. Again the texture, colour and brightness of the destination area are matched. This, too, is useful in portraiture: it can be used, for example, to copy a patch of smooth cheek skin over wrinkled areas under the eyes to banish those wrinkles and produce a flattering portrait.

Noise and noise management

Digital image noise is an unfortunate effect in photography that, to a degree, can be considered analogous to grain on conventional images. Because it is due to low-level electrical fluctuations it is most pronounced when the ISO sensitivity of the camera's sensor is set high (and the noise is therefore amplified) or in dark areas (where the image data itself is low). It is most evident in areas of even tone or low light and shadow regions.

Noise appears as incongruous pixel colours or a banding tone that appears at random across the affected area. The effect can be very distracting and, if you are providing work for a client, it will be deemed unacceptable.

There are several types of noise, ranging from shot noise, which is attributed to random input fluctuations in electrical current (as described above), which is difficult to control, through to flicker noise, which affects certain areas of the spectrum in particular reds. Burst noise, consisting of step tones, is due to bursts of voltage across different levels of the image.

Photoshop can be used to decrease the effects of noise in an image and provides several tools in the form of digital filters (not to be confused with conventional photographic filters) to handle it. These filters can be found by selecting Filter Menu > Noise. The options in this menu are:

• Add Noise
• Despeckle
• Dust and Scratches
• Median

Let us take a look at each of these in turn:

Add Noise can be used to add a controlled uniform amount of **noise** across the image. The net result is rather similar to accentuating the grain in an image. This might be used, then, to impart a grittier feel to an image or to conceal existing noise that cannot be removed using the other tools available in this submenu.

The Despeckle option works by locating the edges in an image and slightly blurring them. This has the effect of softening the sharp edges characteristic or noise, **grain** and **dust**. It is similar (though not as precise) as the Dust & Scratches filter.

The Dust & Scratches filter is useful for removing the worst debris from a file, though if this debris is lighter and more obvious, it might be preferable to use the Clone or Healing Tool on individual blemishes. Dust & Scratches works by searching for and changing dissimilar pixels. Unfortunately this tool cannot discriminate between unwanted dust and scratch marks and fine detail in the image. The consequence of this can be that in removing dust and scratches the image will also be softened. To achieve a balance between sharpening and eliminating defects, it is worth trying various combinations of Threshold, Radius and Median values. These work as follows:

Threshold: this determines how big the difference between the pixels' values should be before they are eliminated.

Radius: this dictates how far the filter will search for differences between the pixels.

Median: this filter will reduce the noise in an image by blending the brightness of pixels in a selected area and will actively discard those pixels whose brightness varies significantly from the **mean** (as dust and noise pixels will). This filter is often promoted for removing the effect of artefacts due to motion in an image as well as conventional noise and grain removal.

noise in digital photography, the interference produced by random fluctuations in an electronic circuit. Noise is most obvious in digital images that are taken using high ISO settings
grain the particles of silver that make up film emulsion, equivalent to noise in digital imaging
dust this generally refers to any damage done to a photograph by dirt or dust on the original film
mean the average

New York skyline (below and following pages)

Although the original print of this photograph was impressive, a combination of cropping, Curves, Dust & Scratches and the addition of noise can make it even more dynamic.

Photographer: Steve Macleod.

Technical summary: Intermediate adjusted image.

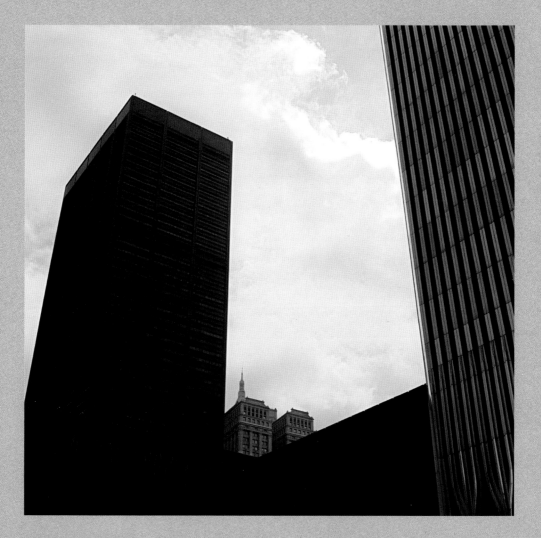

Original print

The original image was from a print RGB scanned into Photoshop and Auto Colour corrected.

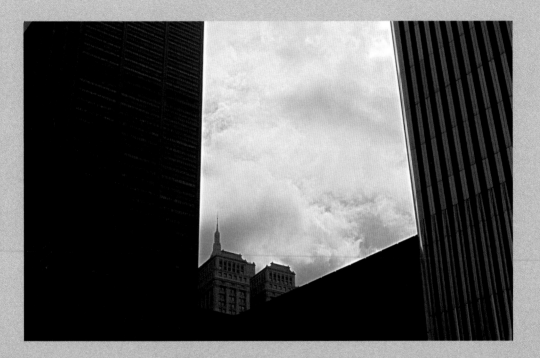

With Curves and Dust & Scratches corrections

A new Curves layer was added to strengthen the contrast in the sky. The Dust & Scratches option was also applied to clean up any specks of dirt that had accumulated throughout the scanning process.

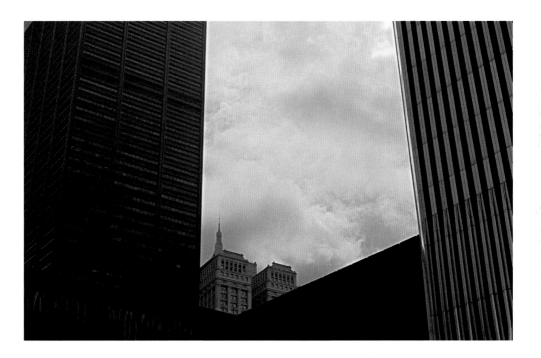

With Add Noise applied

As a result of the Dust & Scratches option, the image became softer, so to create a grittier feel to the image, some median noise with a radius of two pixels was added.

Thai pillars (below and facing page)
The composition of this image was spectacular, but the overall effect was spoilt slightly by the appearance of dust and scratches.
Photographer: Steve Macleod.
Technical summary: Rolleiflex 2.8GX, Kodak 160vc (vivid colour) film, processed normal.

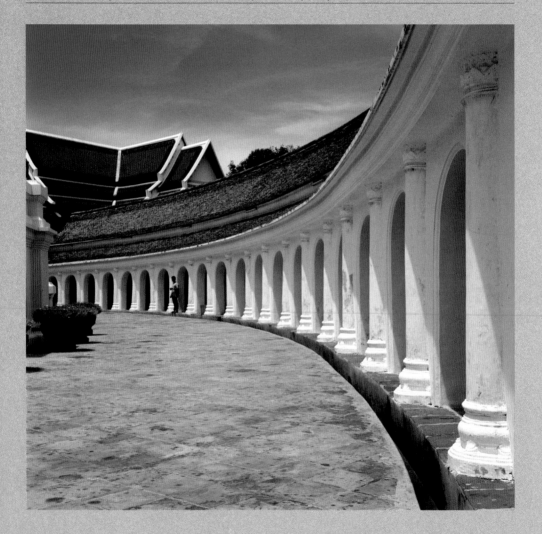

Original image
Shot at the Royal Temple in Bangkok, this is the original image, having been colour balanced.

Retouched image

This image has had the Dust & Scratches option applied, so there is a general softening of the image. The Dust &
Scratches filter was made with a radius of 1 pixel and a threshold level of 1, increasing the contrast slightly. The
annoying blue crate that stuck out in the middle distance was also removed using the Clone and Healing Tools.

Sharpening techniques

Digital image manipulations are powerful and, potentially, quite extensive in their scope. It is often the case, then, that as they are applied to an image they also begin to compromise its quality, particularly with regard to sharpness. The effects of rescaling, cloning and removing dust and scratches can conspire to leave an image that was originally critically sharp a little soft. There are a number of ways to rectify this.

Sharpen

The Sharpen filter applies a modest amount of sharpening across an image. If an image is uniformly soft this can be a good quick-fix solution. However, because it is indiscriminate in its application it can lead to unwanted effects. For example, if there is random noise in the image, this will be enhanced (and rendered more obvious) too. If this is the case, it will be necessary to use the Unsharp Mask instead.

Sharpen More

The Sharpen More filter is a more powerful version of Sharpen, applying approximately four times the sharpening effect. This is too harsh for most real-world situations. It tends to be useful only to demonstrate what the effect of sharpening will be on selected parts of an image. Undo any changes made while experimenting and then apply a similar amount of sharpening – if it is indeed needed – using the Unsharp Mask filter.

Unsharp Mask

The Unsharp Mask is generally accepted as the best sharpening filter and the only one that should be used for critical applications. This option must be performed at the final stage of post-production. To do so earlier may exaggerate noise and as the image is sharpened, image artefacts may appear and degrade the final output. Note also that the blue channels are more prone to noise. The blue channel of any image that is predominantly blue or cyan will require careful attention when using the Unsharp Mask. The Unsharp Mask is discussed in more detail in Chapter 3.

Chairs, Achvarasdale (Facing page)

Images that are soft can be sharpened using a variety of methods in Photoshop.

Photographer: Steve Macleod.

Technical summary: Rolleiflex 2.8 GX, Kodak 400vc (vivid colour) film, drum scanned and worked on in Photoshop.

Original image

The image was shot in soft light so the grain was quite clear.

Sharpened image

After undergoing the colour corrections seen in chapter 3, the image also needed to be sharpened. The grain was quite clear so a threshold level of 6 was used, leaving the image still quite soft.

Inkjet printing

When all corrections and manipulations have been made, images will be ready for print. For most printing tasks today this will mean using an inkjet printer, which, when fed with the right consumables are capable of producing very high-quality images.

Inkjet photo printers are widely available for a range of paper sizes, from A4 to a size slightly larger than A3 called A3+. The latter is sufficient for conveniently printing A3 borderless prints. Larger A2-sized printers are also available but because of their size and the relatively low numbers they are produced in, they command a premium price. Producing A4 and A3 prints in a digital darkroom is a simple and cost-effective matter; for larger sizes – from A2 to A1 or A0 – it is more economic to dispatch them to a professional printing bureau.

Whether printing on a household printer or delegating the task to an outside agency, in order to get a successful print it is important to ensure that the printer is correctly configured. Essentially, this means properly calibrating them to ensure that, gamut considerations apart, the colour you see, adjust and manipulate on screen is accurately reproduced on paper.

The consumables that will keep an inkjet printer fed comprise inks and paper.

Papers

Photographic quality inkjet papers have come into their own in recent years, and are generally classified in terms of weight, brightness and opacity much in the same manner as conventional papers. Where there is a need for long-term storage of images, or archival presentation, there are specialist cotton and wood-free (with no lignin component) papers. Art and specialist papers are very effective at providing the feel of tactile and textured materials and are worth investigating for work suited to the fine art sector.

Most printer manufacturers recommend using a combination of their own inks and papers to achieve successful and stable results, although there are some third-party manufacturers who have developed combinations of their own brand papers or inks.

One of the biggest concerns with inkjet printing is the archival stability of the process. When it was recently discovered that the life expectancies of both Kodak and Lyson's papers and inks were nearer 10 years less than the initial 73-year claim, shock waves rippled through the imaging community.

Heat, humidity and airborne pollutants will all affect the lifespan of any printed media, not just inkjet. Gas fade is a common problem, with images becoming desaturated, losing colour and intensity. In addition to this ozone-based contamination there is a new problem called 'dark fade', which will destroy the print irrevocably. For this reason it is recommended that prints are displayed behind UV reflective glass or sprayed with a protective layer to extend the life span. With the uncertainty over the longevity of inkjet prints (which, it must be said, is neither unproven nor disproven) many buyers of fine art prints in the collecting market are reverting back to photographic means of printing.

Inks

It is usually possible to distinguish a genuine photographic inkjet printer from one that is more suited to general printing by the range of inks provided. Take a look inside the most basic (and cheapest) printer and it will feature three ink colours: yellow, cyan and magenta. Those that command slightly higher prices may add black to this selection to offer true CMYK printing. These will offer prints of a standard that the lay person will consider adequate but which any discerning photographer will immediately realise to be below par.

Photo printers will have a wider range of inks available. This will generally include light magenta and light cyan and possibly light black (grey), as well as other intermediate colours. Some printers and ink manufacturers also offer different ranges of inks for general use and photographic applications.

Users of inkjet printers are generally well satisfied with the results they produce. They will be less satisfied with the longevity of the ink cartridges that can often require replacement after only a few prints. Ink manufacturers have appreciated this shortcoming and many now offer externally mounted ink tanks of high capacity that feed directly to the print heads, but such modifications will only be necessary and worthwhile if the printer is intended for extended print runs.

When comparing the specifications of different printers the formulation of inks will vary according to printer model and manufacturer. These are the principle types available:

Dye-based inks are water-based and feature glycol as the solvent for the coloured dyes. These are the most commonly available and are suitable for general printing as well as photo printing. Some manufacturers produce a premium range, designed especially for archival use.

Pigmented inks are a combination of conventional dye-based inks and pigments. These have greater colour depth and resilience but tend to be problematic when printing on high gloss surfaces. The pigment element is not easily absorbed into the paper and can lead to a finish with uneven gloss.

Full-pigment inks contain no dye elements and use the insoluble action of pigments to reflect light and intensify colour.

'A photographer's reality is what he or she wants to show.'
Fred Picker

Giclee printing

Similar to inkjet printing, is a process known as Giclee printing. Although this is essentially an inkjet process it can trace its origins back to large scale bureaux CMYK proofing printers. Popular in the 1990s, giclee (translated from the French for 'nozzle') gained prominence thanks to the fine art market. They were looking at methods of high-quality print reproduction and discovered something that offered greater image longevity than simple inkjet prints.

Fine art prints were often produced by the industrial Iris pre-press industry. Iris printing was initially used for CMYK proof-printing prior to the final works being shipped to the repro house, therefore the longevity of the Iris print was never an issue (prints were checked for colour then discarded) . Soon Iris prints were becoming popular because of their ability to produce deep saturated tones and a varying nozzle/droplet radius. Giclee stemmed from this application, and it was not long before manufacturers started to use the process to try to identify archivally stable pigment ink media.

Printer and printer driver calibration

As we have seen, most printers aimed at the photographic market use six or eight different inks. A quick and effective way to correct a colour cast that appears at the printing stage is to print using the manual mode. Output a print without making any adjustments to the file. If the profiling and calibration is accurate, the print should match the view on-screen. If not, tweaking the Color Management menu in the printer driver can control the output. This will appear when you select Print from the File menu in Photoshop. Output the file again, unadjusted, and compare this to the screen. If there is an imbalance, go back and open up the Color Management menu. Now adjust the Brightness and Contrast as well as the different colour channel settings; if you refer back to the colour wheel you should be able to make adjustments to compensate for any colour cast.

Reprint the file and make new comparisons. Remember that this is something that should only be done as a temporary fix prior to accurate printer driver calibration. The means and methods of this will vary according to the printer and the driver version that are being used, but both Photoshop and printer software include calibration routines that should be followed for a particular configuration.

PCC Management pop-up menu

This pop-up menu allows the user to make accurate print management adjustments.

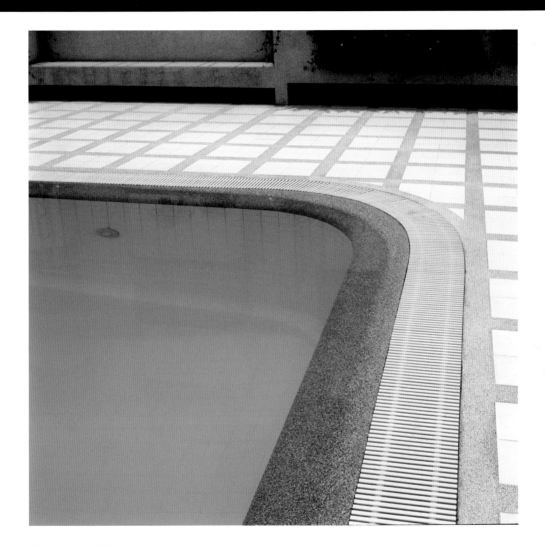

Pool corner (above)

Printed on an Epson Stylus Photo R300 inkjet printer, this image still carries all its original tone and detail.

Photographer: Steve Macleod.

Technical summary: The adjusted image with gradient tone applied.

Digital photographic output

Although the majority of prints today are produced by inkjet printers, some are still produced using photographic methods, though these tend to be the preserve of professional labs and service bureaux.

In professional laboratories devices such as the Durst Lambda™ or Océ LightJet combine RGB lasers to produce a latent image onto standard colour C-type paper (often Fuji Crystal Archive and Kodak Endura papers). Paper comes on a roll and is automatically fed through the machine directly related to the workflow being imaged; the most common size of machine handles 50" rolls. This means that continuous-tone photographic prints can now be produced at a large scale with no loss of detail.

Once the image is exposed the paper is processed through a conventional colour RA-4 processor, and prints have the same archival properties of conventional C-type prints. The Lambda produces prints at two resolution settings: 200 and 400dpi, and the LightJet has three: 200, 305 and 405dpi. The main difference between these devices is the way in which the lasers operate. The Lambda lasers are static and are combined by way of reflectors from a single point whereas Lightjet lasers are suspended on an air rod so that they pass directly in front of the paper media. Some say that this makes the LightJet sharper than the Lambda, but to the naked eye there is no discernable difference – if anything, the LightJet provides more image contrast and the Lambda has a more photographic quality.

The Polielettronica also utilises RGB lasers and uses the same photographic papers, but is more compact and very fast at producing dry-to-dry prints up to 30" x 20" in size.

Faith for sale (below and facing page)

This image has an interesting composition but requires some work to exaggerate the connection between the Pope and the MasterCard sign.

Photographer: Steve Macleod.

Technical summary: Kodak Portra 400vc (vivid colour) film, scanned into Photoshop.

Print realignment

A grid is placed over the image to realign the vertical and horizontal axis of the image.

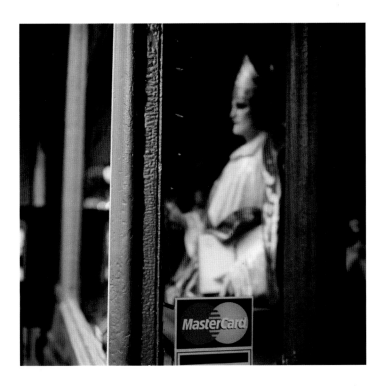

Original image
Here, the image does
not seem to focus on
the two main components
of the image.

Print realigned image
After removing distracting
spots and debris in
Photoshop, the print
perspective is realigned to
draw the viewer's attention
to the image's message.

To gain access to the world of professional photography, it's not just important to be good, it's important to stand out from the crowd. This can be both difficult and daunting but with guidance on presentation and self-publication, it is possible. There are no promises – any photographer will stand or fall on the quality of their work – but there are a number of pointers and tools with which you can make the best of all potential opportunities.

There is no doubt that a photographer's images will be their premier sales tool; great images and great presentation. Whether online or physical, they comprise a portfolio and this is the best advertisement. It is a sad but true fact that too many very competent photographers fail to impress their clients because of poor promotion and presentation. Here, issues of self-promotion and presentation will be discussed, beginning with a look at developing awareness and a presence: creating and maintaining a website. Then issues surrounding the development of a portfolio are addressed. How can it be presented? Does it have to be a collection of paper prints? The chapter will conclude by looking at another avenue for self-promotion: the fine-art marketplace.

'You sepia tone a bad print, and what you get is a bad sepia toned print.'
Linda Cooley

Pool, Liberia (facing page)
Jon Nicholson is very professional when it comes to presentation: his website is up to date, his work is immaculately produced and everything is thought through to maximise the impact of his incredible body of work.

Photographer: Jon Nicholson.

Technical summary: Original transparency scanned on Nikon COOLSCAN 9000 ED input into Photoshop.

Websites

Traditionally (by which we mean until very recently) a photographer who was setting out on the road to become a professional would often use an agent to help them gain the first step on the ladder. Clients who were looking for a particular style or type of photography would, rather than seek out a photographer directly, approach one or more agents to let them undertake the pre-selection process. This method is as valid today as it was in the past, but the birth of the photographer's website has made the whole process very much easier.

So where does the photographer begin with a website? With the necessary skills it is easy to set one up straight away, showcasing the best of your images. If not, you might want someone else to do this essential work for you. Either way it is important to begin by planning.

Designing a photographer's website

Remember that a site should only be an introduction to your work, or to advertise new projects. Providing website details to a prospective client is not enough on its own, though it goes a long way in support of a portfolio and being taken seriously. Before designing and having a site built, consider what it is that you want from it. Look at other photographers' sites, especially those that you aspire to, see how their work is presented, and find sites that work well. Again keep it simple, user-friendly and informative, and include any personal work or a biography. Set about the design methodically and consider what should be included. Start with the following:

- Images
- Navigation
- Contact details
- Personal information

Perou

Perou has a great website, which includes his commercial work, biography, a blog and diary entries – endless entertainment.

Images

Perhaps rather obviously, images are the most important element of the website and it will be for these that visitors will be browsing. Those who do visit may not have much time on their hands and will want to gain access to images very quickly and, having done so, swiftly assimilate your style. If they like it, they will look deeper; if not, they will move on. This is why it is important to select your best images and the key genres that you cover.

Navigation

This is where many self-taught website designers fall down. It is crucial that a visitor can get around a website easily. They will not have the time to have to explore a clever but initially baffling website. Allow visitors to quickly get to the best of a collection. This is the hook that will hold them and encourage them to explore a little deeper. A website can look good at the same time as being easy to get around.

Contact details

It is surprising how many websites do not provide this information when first set up. Contact details should allow visitors to get in touch using the means of contact they prefer, whether this is by telephone, mobile phone, email or even post. Make sure all bases are covered.

Personal information

As an adjunct to contact details, it is useful to give some personal information. Talk about the type of work you undertake, and support it with details of any assignments you already have. If you have been successful in winning awards or accolades don't forget to mention these too. Ensure that professional qualifications stand out!

Some photographers' websites have additional media such as video, audio or flash animations. These can make websites more fun to visit, but can also annoy some visitors. If such media actively contributes to the website use only as much as is needed and with great care.

'Personal choice can often take a back seat when 'someone else' is paying the bill.'
Jill Enfield

Creating a website

Once all the essentials for your website have been put together, consider whether you can do the job of producing the website yourself or if it would be more sensible to contract the work out. It is often better to opt for the latter, on the following bases:

- It allows you to concentrate on your photography
- The end product will be professionally designed and kept
- Any technical glitches can be resolved professionally
- The 'back office' work (having the website hosted, arranging web addresses etc.) are all taken care of by the designer

Against this, of course, it is important to balance the cost. A glance at the photographic press will show a number of companies offering to take care of website design and management for photographers. The best part of this is that it is clear to see and use any references provided by them. Visit the sites they have created for other photographers. How do the sites look? How well can you navigate them? Do all the sites look distinctive or are they all very similar? Is the cost realistic? Many companies will also set up a demonstration site that can be previewed before any commitment is made: it is an opportunity that is well worth taking advantage of.

Bear in mind too that commercial website creation companies can provide value-added features. For example, should you wish, perhaps at a later date, to include an online store to sell images, they can easily slot this in . They can also add extra features to make the website more prominent in searches made by search engines.

Publishing a website

If you do decide to go your own way, be mindful of the task: not only will you have to take care of the production of the website (along with any updating and day-to-day management) but you'll be in charge of the publishing too. Publishing is the process of setting up a website on to the internet so that people are actually able to visit it. For this a web address must be acquired as well as the 'space' on which the website will operate. Bandwidth (the amount of data transfer capacity) required to allow people to visit and examine images will also need to be considered. Usually all these tasks can be taken care of on your behalf but, if you have decided to go your own way you will need to:

- Acquire web space from a website host
- Determine the bandwidth required
- Upload your website
- Acquire a web name and point your website to it

Finding someone to host a website is comparatively easy and cheap. A quick search via a search engine will reveal a number of potential hosts, but it is also sensible to turn to friends and colleagues for advice. Who do they use? Who do they recommend? More to the point, whom do they not recommend? Pricing tends to be proportional to the space needed. Make sure that, when constructing your site, you have a good handle for the size now, and a good

idea of how much will be needed in, say six months. Most hosting sites will allow clients to upgrade as time goes on, so don't be too ambitious at first. The same goes for bandwidth. Prices increase as more bandwidth is required but, in the early days, the amount of bandwidth needed will probably be very low.

Once web space has been acquired, your website will need to be uploaded. The host you use will probably give you the tools to do so or else will be able to point you in the direction of some free or low-cost tools.

The final step is to give your website a good name. Your website hosting site will often require that you type a complex and forgettable web address into your web browser to access the site. If you don't remember it you can be sure that potential visitors won't either. Instead, your website needs to have a more memorable address. Sites that specialise in registering web addresses allow users to register a web address as well as checking to see which addresses are still available. Try a few alternatives if your first and second choices are already taken – using 'studio' or 'photography' in conjunction with a name will usually offer more alternatives.

Purchase the corresponding web address (again the cost is nominal) and, once the purchase is approved, you can direct any traffic that goes to this address on to your website. This can all be done at the same website from which the address name was purchased.

Ultimately, a photographer's website will be a promotional tool, but in order for it to be effective, it will need, in the first place, to attract visitors. To help with this, ensure that it is your website that comes up when someone types your name, studio name, or anything else connected with you into a search engine. It is possible to speed up the process by adding certain keywords into the website (again, if the website is being produced for you, your designer can ensure this happens). More conventionally you can try some – or all – of the following:

- Straightforward advertising in the specialist press
- Newsletters
- Links from and to other photographic websites (reciprocal arrangements)
- Submitting your details to key trade directories

Print portfolios

Although there are several ways of physically presenting work to prospective clients, the most common is the print portfolio. The traditional portfolio – still popular and accepted today – comprises a bound folio with plastic sleeves to hold prints, making it easy to update and replace damaged prints when necessary. The way that images are formatted is down to personal taste, but essentially folios must flow. Start with something strong and eye-catching. Then move down a gear – not in quality but style – then up again in the middle, down again, and finish up on a high.

Do not overload the portfolio; a selection of 15–20 images will give the client a good idea of the quality of your work and your style – without them becoming bored.

Styles and types

Keep the format and layout of the prints simple. Popular formats include:

- Traditional, with wide borders, possibly bottom-weighted (with a wider bottom border)
- Full bleed, edge-to-edge prints
- Half frame, where the images cover half the page with full bleed top, left and right
- Centred, full bleed left and right with borders top and bottom

The subject of your prints may well suggest to you which looks the best.

Another popular method of print presentation is to provide sleeved prints as a boxed set. This is a good way of showing a selection of prints all laid out together, though it does run the risk of prints going missing as they are not fixed to any binding. Use this method for one-on-one presentations, particularly if prospective gallery curators or collectors are involved. This method also works well when your work is going to be assessed by a group, board or a committee: it is easier for prints to be passed around several people simultaneously.

Portfolio content should reflect a photographer's typical work, that which is undertaken most often and that the photographer feels most confident in. If you have a particular speciality that does not fit a precise genre (for example, if your area of expertise is high colour, high saturation images – whether of weddings, travel or landscape) it would be very wise to produce two or more portfolios to fit in with the formats typically accepted by clients, for example, two separate portfolios for travel photography and landscape photography.

Should you have, by this stage, taken on an agent, you can then give the agent your collection of portfolios and allow them to make the judgement call when a client makes a request. There is actually a very fine line between fulfilling a brief and providing something stunning but irrelevant. Sadly, the art directors of most clients are on a tight schedule and will not have the time to look in-depth at each submission. Think about your portfolio as you would your CV or résumé. Your career history is the same no matter what position you might apply for. However, if you are applying for a specific position that requires certain skills you are likely to emphasise and expand on these. So your portfolio needs to provide similar emphasis.

Electronic portfolios

Today portfolios don't always need to be presented in the traditional book form. Your client may be happy – or may even specify – that you should provide your portfolio in electronic form. You might then provide your collection of images on CD or DVD. If you do need to do so, the presentation should be in no way inferior to what you would submit in a traditional form. It should also be rigorously tested before sending to a client: if, for whatever technical reason the presentation just doesn't work on the client's computer, it will be dismissed.

Some photographers who submit in this way will submit a disk version of their website. This is much more acceptable than just a collection of images saved to a disk and allows viewers to browse images with the same convenience that they would on your website. The key difference is that on disk you don't need to supply small, compressed images in the same way that you do on the website. Image files can be larger so that, when viewed on-screen or projected, they will have far more impact.

Personal presentations

If a photographer is asked to make a personal pitch to a prospective client, this is because, whether via website, portfolio or just word of mouth, something has caught the client's eye. It is important that, if the photographer is fortunate enough to reach this stage, they use the opportunity to their greatest advantage.

Preparation

Preparation is essential when approaching a personal presentation. To take the job application analogy a step further, think of this as a formal interview. It is important to ensure that your images and portfolio are in tip-top condition; research the client and, where possible, study their needs with regard to the job in hand. It is vital to be thoroughly professional in your approach and, equally, confident.

The presentation

When attending the presentation it is important to be armed with all the material for the presentation, in the form the client expects. This material should complement that which the client will have already seen. Perhaps the client has seen something in your style or approach and commented – to you or your agent. Use this as the basis of the collection and show them more (and possibly more powerful) examples.

You may want to demonstrate what else you are capable of; be careful in doing so. Do not stray too far from the brief as this may dilute your prime offering – that which got you the pitch in the first place. Follow the example of established photographers who will attend a brief armed with a laptop computer and a series of alternate presentations. Show the client what they want to see and, only if they request it, show some of your alternative works. Also consider leaving them a copy of these on CD or DVD so that the client has something to remind them of you later, when they come to make their final decision. These too should be professionally put together and also presented well. Print labels for the discs, providing contact details and a summary of what is on the disk. Consider also producing a CD or DVD case with an attractive insert to showcase an image and your contact details again. You might want to leave this along with a hardbound book of your images.

Afterwards

Occasionally, personal presentations are held just to confirm the photographer's suitability for the role and for the client to secure their services. This does tend to be the exception, however. The client may well have shortlisted several photographers who they need to consider. It might be that none meet their expectations, or it might be that two or three do and there will be a need for a second presentation.

Getting your first commission is hard but you will learn from every presentation and proposal that you make. If you are turned down, do not expect the client to give you reasons why, as they may well be too busy to do so, but if you do get some advice take it on board. If you have worked via an agent then they may be able to get some feedback.

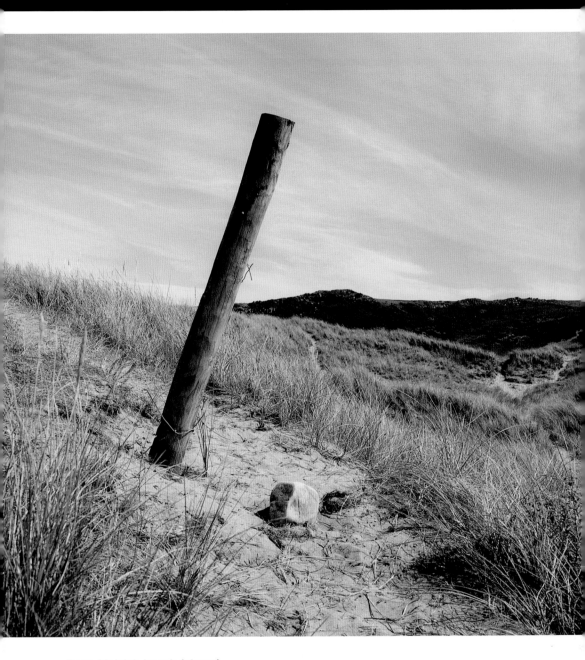

Post, Melvich beach (above)

From a series produced based on feelings of isolation, inspired by everyday objects that we often overlook.

Photographer: Steve Macleod.

Technical summary: Rolleiflex 2.8GX, Kodak Portra 160nc (natural colour), printed on Kodak Endura glossy paper.

Exhibitions, fine-art printing and image libraries

Whether it is down to the resurgence in interest in photography due to digital technology or increasing wealth, the photographic art market is more buoyant now than it has ever been. Photographic art has become very collectable and is now considered to be on an equal footing to other art forms. With this increase in demand for photographic prints, so too have expectations been raised. Therefore it is imperative that fine-art printing is undertaken with professionalism and sensitivity.

As your skills improve and the quality of your work becomes more widely recognised (whether that is due to some work for high-profile clients, or general market awareness), you have some other potential outlets for your prints: edition printing and exhibitions.

Edition printing

Edition printing is a popular method of outputting work. An edition is rather like a run of books from a publisher. Like a book publisher, you will need to determine first what size prints you will want to offer, the medium to be used and the size of the run. Do not be tempted to do large runs. It is best to limit a run to, say, 15 and to release the edition in stages. That way people realise that there are very few of these prints going to be made, and as the edition runs out, a higher price can be demanded.

Galleries and exhibitions

Holding an exhibition at a gallery or having selected prints displayed by a gallery is another way of selling prints. When approaching a gallery, make sure it is one that will show your style of material. Research what has been shown before and the demographic.

When it comes to presentation, not only must you consider the printed image, you must also be able to back up the work with a thesis or biography for the material. This is critically important when it comes to placing the work in context with similar subjects and in promoting the exhibition.

Authenticity and archival stability go hand in hand with collectors and you must be able to substantiate any claims in regard to your work. Editions must be numbered and a careful track of what is being done and where it is likely to end up, are essential. Also be prepared to hand over between 30–50 per cent of any profit from sales to the gallery.

Image libraries

The most popular outlet for images today tends to be image libraries. The voracious appetite of the media for visual material means there is a ready market for images of all types from the fine-art type through reportage-style image and on to simple, graphic-type images.

There are many libraries around and again it is wise to research them before submitting a collection. Some of these libraries are indiscriminate: they take images from just about anyone and everyone. Of course, the standard of images in these tends to be lower than those that pre-qualify the submissions and the photographers. However these libraries also tend to charge users of images less and so the returns are lower. Whatever type of library you approach, do be careful: if you have good images the library will want them on their books. And this will be reflected in the proposal or contract they give you. Still, be prepared for royalties from sales to be split fifty-fifty with the library; this is quite normal.

Collaborations

A screen grab from a keynote presentation that I show students. It centres on the idea that you don't only have to be a photographer to be involved in the image-making process.

Conclusion

If the official statistics are to be believed (and there is no reason not to), the number of photographs shot over the last quarter of a century have risen substantially year on year. Far from becoming a specialist hobby, as many pundits had predicted, photography has entered the mainstream. There is no doubt that digital photography has played a major part in this: the immediacy of results and the competence of the cameras, along with the range of cameras available, have played no small part in this.

The vast majority of these photographs have been shot in colour (black-and-white photography is still perceived in the mass marketplace as either 'old' or 'arty') but, disappointingly, very few of these images are seen at their best. Because so many photographs are taken with fully automatic cameras and without due deference being paid to the nuances of exposure and colour, the professional photographer has a head start. With skills in both shooting and print production, he or she can produce prints that are both more authentic and more powerful than those that people in general are used to seeing.

The shape of the market over the last few years (in particular) has meant that colour film is less widely available; digital techniques have made greater inroads here than they have for black and white. We should not be disparaging about this. As you will have seen, colour film processing (and the subsequent printing) does tend to be more prohibitive than black and white. The opportunities to manipulate and enhance images in the conventional darkroom are more limited and, often, more tricky.

It is not surprising then that many professional colour photographers were amongst the vanguard of digital photographers. They could take the skills developed in black-and-white photography and extend them in the digital darkroom to their colour printing.

There is certainly no need to feel in any way that digital working is second best. Your aim as a photographer, no matter what genre or genres you choose to specialise in, is to produce the best possible imagery. It is important to bear in mind that today the production of a print is by no means the final – nor the only – medium for that imagery. Your images are equally likely to be viewed online, from a CD or DVD, or in books and publications.

Your skill and, ultimately, your success in colour post-production relies on a comprehensive command of the skills discussed in this book even if, ultimately, you don't use them day to day. That includes presentational skills: today, sadly, photographs rarely sell themselves. Success? It's down to shooting first-rate photographs, good post-production skills and selling yourself. Deliver on all three and you've all the tools to become a great photographer.

Evening sun (above)

Shot on a compact camera in the early evening sun, the simplicity and depth of this image brilliantly captures those last few rays of sun.

Photographer: Steve Macleod.

Technical summary: Canon Powershot, 2mb jpeg file, cropped and adjusted in iPhoto.

Analogue
A method of recording data in its original form in a continuously varying way, rather than in numerical form, as in digital recording. Conventional film photography is an example of analogue data recording.

Aperture
The adjustable opening in a lens that allows light to enter a camera.

Application
Software programme.

Artefact
A visible fault in a digital file, most apparent in over-compressed jpeg files.

Banding
A visible stepping effect where image tone should appear smooth.

Bit
A binary unit that is the smallest unit of information used by computers.

Bitdepth
The total number of graduations of tone or colour in an image, the higher the number the greater the detail.

Bitmap
A digital image made up of a grid of pixels.

Bracketing
A method of establishing the correct exposure by taking several photographs with more or less exposure each time.

Burning
Exposing certain areas of a print more than others.

Byte
Eight bits of data make one byte.

C-41
The standard colour negative film processing chemistry.

Calibration
The correlation of colours in a computer display with those of a standard set. It is important to calibrate monitors and other peripheral displays so that they display colours accurately.

Canvas
The outside picture area in which an image sits for manipulation.

CCD
Charge-coupled device, a chip that converts light into electrical signals.

CD-R
A compact disc that can record information once.

CD-R/W
An erasable compact disc that can be reused.

Channels
Individual colour components of an RGB or CMYK image.

Chromogenic
A process where traditional silver is first formed and then replaced by coloured dyes. Each layer of emulsion incorporates coloured dye couplers. Once processed, the dye adheres to areas where the silver is still present.

Clipping
The parts of an image that cannot be accurately printed are often clipped.

Cloning Tool
A Photoshop tool used for copying one area of an image into another.

CMOS
An image sensor using alternative technology to the CCD. It is preferred for some situations because of its low power consumption.

CMYK
Abbreviation for cyan, magenta, yellow and black. CMYK is used to reproduce colour on printed media and has a narrower colour gamut than RGB.

Colour cast
An overall tone that affects the representation of individual colours in an image.

Colour management
A system that allows for the control of variations between various imaging devices.

Colour Picker
A Photoshop tool that allows for accurate colour selection.

Colour space
Different colour spaces have larger or smaller working gamuts; RGB is smaller than Adobe 1998.

Compression
A way of storing a digital image file by first compressing the data to allow more images to be stored on a memory card.

Contrast
Differences in colour and tone in an image.

CPU
Central processing unit, the heart of any computer, receives, evaluates and performs functions.

CRT
Cathode ray tube monitors are bulky but still offer the best in colour translation.

Curves
A feature of most image manipulation applications that allows the input and output values of colour, brightness and contrast to be varied.

Data
The information on which a computer operates, which can be stored or transmitted.

Developer
The primary chemical that converts latent film to visible silver halides. Also used to describe photographic paper developing agent.

Digital
The representation of data (an image, video or audio track) as a digital code that can be interpreted by a computer. Unlike analogue, this code can be easily and effectively copied and modified.

Dodging
Exposing certain areas of a print less than others.

Downloading
The process of transferring data from a peripheral to a computer.

DPI
Dots per inch, this is the measurement of image size once printed and does not represent resolution.

Drum scanner
A high-end PMT laser device that can scan reflective and transmitted light objects.

Duotone
A method that uses two inks to increase tonal range in printed media.

Dust
This generally refers to any damage done to a photograph by dirt or dust on the original film.

DVD
A digital versatile disk, which has high capacity storage, offering six times more than a CD.

Dye couplers
Chemicals that form visible dyes when they react with processing chemistry.

Dye inks
Dye-based inks used by printers offering rapid drying times and a vibrant range of colour. Not suitable for archival printing.

Dynamic range
The range of information from light to dark that a CCD can distinguish.

E6
Standard processing chemistry for positive colour reversal (slide) film.

Emulsion
The coating of light-sensitive material used in the production of photographic film and papers.

Enlarger
An optical device for making prints from negatives, in a colour darkroom the environment is completely light-tight.

Feathering
A process which softens edges in pixel increments to prevent jagged edges appearing.

File size
A file's size is determined by the amount of data that it contains.

Filter
In analogue photography, this is a coloured screen that covers the camera lens or controls the contrast in darkroom enlargers. In digital photography it refers to a manipulation application process.

Filtration
The process whereby the amount of coloured light emitted by the enlarger is controlled.

Firmware
Permanent software programmed into a computer.

F-stop
The aperture setting of a lens to control the amount of light hitting the film plane or CCD.

Gamma
The method of setting monitor contrast; for Windows this is 2.2, Macs 1.8.

Gamut
A representation of the extent of a colour pallet used for printing, displaying or recording a digital image.

Gigabyte
1,073,741,824 bytes make a gigabyte (GB).

Grain
The particles of silver that make up film emulsion, equivalent to noise in digital imaging.

Greyscale
An image made up of a range of grey tones, from black (0) to white (255).

Halides
Compounds of a halogen with another element or group. These are suspended in each layer of film and are later bleached out to reveal the captured image.

Hard drive
The component within a computer that stores data.

Healing Brush
A Photoshop tool which is similar to the clone tool, but better!

Highlights
The brightest part of an image. In digital images these are represented by 225 on tonal scales.

Histogram
A graphical representation of a digital file, useful for setting the correct exposure in camera.

ICC colour profile
(International Colour Consortium) a standard (or set of standards) for colour in cross-platform and cross-device applications.

Image resolution
The number of pixels stored in a digital image.

Inkjet printer
A computer printer that uses a technique where minute quantities of ink are sprayed on to paper. Many inkjet printers can produce photo prints, but some – those with more ink colours – offer a far higher quality of printing.

Interface
The point at which two systems meet.

Interpolated resolution
The resolution that can be obtained by cloning intermediate pixel values in order to mathematically increase the number of pixels in an image.

Interpolation
A process of increasing image size where extra pixels are cloned based on values of existing pixels.

ISO rating
International Standardization Organization: in photography, used to denote the sensitivity of film and the equivalent sensitivity of an image sensor. Higher numbers indicate higher sensitivity. This rating has superseded the previous (and identically scaled) ASA rating.

JPEG
Joint Photographic Experts Group: this is the format which is commonly used to compress and transmit low resolution images.

Layers
A Photoshop feature that enables different elements of a file to be stored in an application. Layers can be separated and worked on before culminating in the final image output.

LCD
Liquid crystal diode display, most commonly the small screen on the back of cameras which allows previews to be viewed.

Levels
A feature of most image manipulation applications that allows the user to adjust highlight, mid-tone and shadow details of an image.

Lossless compression
A process of compressing images without sacrificing quality – most common is the TIFF.

Lossy compression
A type of file compression that compresses the file to a much greater degree than with lossless compression. It does this by discarding some of the data. When the image is restored there is a drop in quality proportional to the amount of compression.

Marquee tool
A manipulation tool used for making a rectangle, square, elliptical or circle selection.

Mean
An average.

Megabyte
1,048,579 bytes make a megabyte (MB).

Megapixel
A digital term, a megapixel is approximately one million pixels.

Metamerism
The build up of red, green and blue dots, which are used to display colour.

Negative
A widely used term for both black-and-white and colour photography film. The emulsion captures light in opposite wavelengths from the subject and, once processed, the image tones are reversed, thus the term negative.

Neutral
Areas of a photograph that have a pale grey, cream or beige tone.

Noise
In digital photography, the interference produced by random fluctuations in an electronic circuit. Noise is most obvious in digital images that are taken using high ISO settings.

Optical resolution
The actual resolution, not interpolated or digital resolution.

Pigment inks
A more stable ink than dye-based media, lasting approximately 100 years, depending on storage methods.

Pixel
(Contraction of picture element)
the individual elements that
comprise an image sensor and,
consequently, a digital image.

Positive
A type of photographic film
used for colour slides and
transparencies. The lights,
shades and colours are a
true representation of the
original object.

PPI
Points per inch, which is used by
scanners to define quality. The
higher the PPI, the greater amount
of detail to be rendered.

PSD
The native Photoshop file format
which will preserve layers
contained within an image.

RA-4
A common term to describe the
processing of colour papers
post-exposure.

Rangefinder
An optical device that aids in
assessing distance and focus
of a subject, viewed from within
a camera.

Reflective
The method of scanning prints,
where light cannot pass through
the media being scanned.

Resolution
The amount of detail that can be
resolved in an image. It is
determined by the resolving
power of the lens (i.e. how sharp
the lens is), the grain structure of
film or the number of pixels that
comprise the image. Higher
resolution images contain more
detail and can be enlarged further
when printing without the grain or
pixel nature becoming visible.

RGB
Red, green and blue, the colours
used for displaying an image on a
screen. Each colour has 256
shades and can combine to
create 16.7 million colours.

Saturation
The intensity of colour in an
image, usually measured in
comparison to white.

Selection
An area that has been selected
within a digital application.

Shadows
The darkest part of an image and
the converse of highlights. In a
digital image the shadow is
represented by tone 0.

Sharpening
A process of increasing
contrast and edge definition
in a digital image.

SLR
Single lens reflex camera.
For both film and digital 35mm
equivalent formats; the
advantage with digital is that the
image shot is directly translated
to the preview pane. Digital
SLRs are faster than compact
digital cameras.

Software
The programmes and operating
systems used by a computer.

Stop
Also f-stop, a standardised
measure of the opening of a lens
aperture. Each subsequent f-stop
(when numerically increasing)
represents an aperture one half of
the previous (e.g. f2, f2.8, f4, f5.6).

Tag
Images can be assigned a unique
keyword through which they can
be easily identified.

Test strip
A strip of print where the negative
is exposed for varying amounts of
time in order to assess exposure
density and colour balance.

TIFF
Tagged image file format. An
image format that works across
many computer platforms.

Tone
The overall effect of colour, light
and shade in an image.

Transmissive
The method of scanning slides
and transparencies, where the
light is transmitted through the
media being scanned.

Tungsten lighting
A glowing electric light bulb with
a tungsten metal filament. Its
effect can be seen and judged,
unlike flash.

TWAIN
An interface that allows
the computer to control
the scanning device.

Unsharp Mask
A method of sharpening image
quality that is very adaptable.

USB
Universal serial bus, a
communications system between
a computer and peripherals
(including cameras) for the
transfer of data.

White balance
Custom balance on a digital
camera will achieve accurate
colour rendering. Point the
camera at a sheet of white paper
in any given location and the
camera will compensate.

Acknowledgements

I would like to thank all the photographers and others who have generously allowed me to use their images for this publication.

Thank you to all those that have guided me on a technical level in my research.

I would also like to thank Brian Morris for convincing me to do this, to Leafy Robinson, Caroline Walmsley and Peter Cope for their patience and support in making this happen, and to Gavin Ambrose for the fantastic layout and design.

Dedicated to my long-suffering wife Claire and daughter Milli – now I have time to play!